An exhibition organised by the Arts Council of Great Britain

Stanley Spencer 1891-1959

Brighton Art Gallery 24 *July to* 22 *August* 1976

Glasgow Art Gallery and Museum 4 *September to* 10 *October* 1976

Leeds City Art Gallery 23 *October to* 21 *November* 1976

Fitzwilliam Museum, Cambridge 4 *December* 1976 *to* 9 *January* 1977

The Arts Council 1976

Cover illustration: *Self-portrait* 1939 (no. 39)
Fitzwilliam Museum, Cambridge

© Arts Council of Great Britain 1976

ISBN 0 7287 0094 8

Arts Council organisers: Andrew Dempsey
with Patricia Cowan

Designed and produced by
Ruari McLean Associates Ltd,
Dollar, Scotland FK14 7PT

Printed and bound in Great Britain by
Robert MacLehose & Co. Ltd, Glasgow G13 1HX

Photo credits: The Arts Council gratefully
acknowledges the following photographic agencies:
Photo Studios Ltd, John R. Freeman & Co.,
A. C. Cooper Ltd, West Park Studios, Frank
Kenworthy, Prudence Cumming Associates Ltd

Contents

Acknowledgements

For many years there have been regular and valuable Stanley Spencer exhibitions at the Spencer Gallery in Cookham. However, this is the first attempt to survey his work since the 1963 memorial exhibition in Plymouth and the Tate Gallery's retrospective in 1955. As such it is long overdue and will, we think, lead to a re-appraisal of Spencer's achievement.

The exhibition was proposed to us by Duncan Robinson of the Fitzwilliam Museum in Cambridge. He has selected and catalogued the exhibition, and advised us in countless ways. We are greatly indebted to him and to the other catalogue contributors, Mrs Carolyn Leder, Mr Antony Gormley, Mr Robin Johnson and Mr Richard Carline. In addition to writing a personal memoir, Mr Carline has been a constant help to us in researching the exhibition. His help, and the co-operation of the artist's two daughters, Shirin and Unity, has been particularly appreciated by the exhibition organisers.

The Stanley Spencer Gallery in Cookham has collaborated fully, lending to the exhibition and providing much information and assistance of a practical nature. We would especially like to thank Mr Geoffrey Robinson, Chairman of the Trustees' Committee, and Mrs Joan George, Honorary Secretary.

Lenders to the exhibition are listed elsewhere in the catalogue. A considerable number of the loans come from private collectors and we are very grateful indeed for having been given permission to borrow not just for one showing but for four. Lastly we should like to thank our colleagues in the four galleries where the exhibition is to be held for co-operating so fully.

ROBIN CAMPBELL
Director of Art

JOANNA DREW
Director of Exhibitions

Introduction

When Stanley Spencer resigned from the Royal Academy in 1935, he hit the headlines. Far from objecting to the publicity, he appears from his statements to the press to have enjoyed the attention and notoriety he earned by quarrelling with the Establishment. 'I never wanted to become an associate,' he told a *Standard* reporter, 'I do not approve of the Academy, but I thought the best way to change it was to join it.' From the small print an apparent isolation emerges in Spencer's position as an artist. Isolated from academic approval, he was no less so from popular taste. 'Nobody challenges Spencer's ability as a craftsman, the skill of his hand,' one fairly sympathetic reviewer wrote of *Workmen in the Houss* (no. 25), 'what many people object to are some of his subjects when these are imaginative conceptions.' The subject of this particular canvas, with its testimonial to the dignity of labour, was potentially popular in England between the wars, but its treatment involves figures which did not conform either to the canons of popular taste or to the standards of academic realism. Nor for that matter did they appeal to an avant-garde in pursuit of formal abstraction.

For a number of years, it seemed that Spencer's direction was wilfully personal; the exploration of a private world increasingly introverted and inaccessible to potential admirers. The artist who had enjoyed in his youth, partly as a result of his time at the Slade School, a wide circle of contacts and friends had become, by 1939, a recluse. Like so many of his works, the series of paintings *In the Wilderness* is autobiographical. Yet Spencer emerged as the widely acclaimed Official War Artist of the Glasgow shipyards. By the end of his life his reputation was assured, and confirmed by distinctions which included, not without a certain irony, his re-instatement and election to full membership of the Royal Academy.

Yet in one important respect Spencer's old isolation lingered. His critics continued to treat him apart as a solitary artistic phenomenon. Like Augustus John he was described as 'an English individualist', when the common origins of both artists in the Slade School might have encouraged a broader view. However, such a drastic revision of critical assumptions could not be expected from a generation of critics brought up in accordance with the precepts of Roger Fry. No-one challenged Paris as the centre of the artistic world or the notion that significant developments in art were formal ones. By such standards, a painter like Spencer whose work was both figurative and narrative could hardly be judged fairly. A special, provincial plea could be entered on his behalf, but the best defence of his stature as an artist remained his individuality. That in turn allowed recourse to the past. Spencer was compared not with his contemporaries but with William Blake, for whom he had conveniently admitted his admiration. He was thus identified, inappropriately, with a literary tradition in English art. As Eric Newton wrote in 1947, 'with him each picture is a statement of a particular message, an illustration of a specific idea in pictorial form.' It is to counter this view of Spencer as the isolated illustrator of an eccentric vision that the present exhibition is organised.

Its aim is simple, to let the pictures speak for themselves, and to encourage a re-appraisal of the artist. The essays in the catalogue are designed to contribute towards that end. They are arranged so that they treat important aspects of Spencer's career in chronological order and from different standpoints. They also serve to compensate for unavoidable gaps in the exhibition. The Burghclere Chapel paintings are an obvious and inevitable omission. No less unfortunate is the small number of early pictures which could be included. More of them would have illustrated better what both Richard Carline and Carolyn Leder stress, the importance of Spencer's training at the Slade. His draughtsmanship remained, throughout his career, a reminder of it. Equally characteristic are the simplified, block-like figures painted to represent *John Donne arriving in Heaven* (no. 1). Similar formal exercises in the work of Spencer's fellow-student, C. R. W. Nevinson, led a few years later, to the planar abstractions of English futurism.

Like his contemporaries at the Slade, Spencer proved susceptible to influence from those artists included in the Grafton Galleries' Post-Impressionist exhibitions, above all to Gauguin, whose brand of

primitive mysticism had more than a little to do with the pictorial embodiment of Spencer's own vision of Cookham as the New Jerusalem. To attribute such influence indirectly to the Slade seems fair; in spite of Tonks's disapproval of Roger Fry's avant-garde parades, his students united in their enthusiasm for them. To some extent the exhibitions confirmed existing interests and loyalties. Augustus John, for instance, revealed his knowledge of French symbolist painting in *The Way Down to the Sea*, 1909–11. In Spencer's immediate circle his brother Gilbert and his future wife Hilda Carline rendered their tributes in an equally Slade School idiom.

In the years following the First World War Spencer was preoccupied with his experiences on the Macedonian front. Again, he may be compared with a number of his contemporaries who worked, officially or unofficially, as artists of the Great War. For some of them, for David Bomberg and Wyndham Lewis in particular, there were at times conflicts between their artistic interests in abstraction and the demands of their patrons for recognisable paintings in commemoration of specific action. Not so for Spencer, for whom the human figure and the human situation were fundamentals of art. Of them and of his own intensely human response to trench warfare the Burghclere Chapel is the apogee. In contrast with those artists who were excited by the cold-steel mechanisation of warfare, and blasted out of it their machine aesthetics, Spencer remained a muddy-booted humanist. For all the differences, the Burghclere Chapel paintings find a literary parallel in the everyday speech and earthy wit of David Jones's *In Parenthesis* of 1937.

This is not to deny that Spencer responded, as he had done before the war, to current developments in the visual arts. During the 'thirties, he simplified the anatomy of his figures until they seem to express that aspiration towards the cylinder and the cone which characterises the figure style of William Roberts at the same time. It seems reasonable to suppose that both artists were impressed by what Léger had done to the inhabitants of his cities more than a decade earlier. They were not alone; among their slightly younger contemporaries, Henry Moore was looking in the same direction. With Roberts, Spencer also shared his admiration for the common man. His world was less mundane perhaps, especially in his later work, but it is similarly peopled and often depicted, as Richard Carline points out, from a seat on the top of the omnibus. It is a measure of Spencer's populism that he sought to give such a commonplace explanation of his characteristic perspective, with its high viewpoint.

Inspired by the tangible success of the Burghclere Chapel, Spencer went on to project a series of Cookham Chapels in which he could unfold his entire *comédie humaine*. Antony Gormley explains the development of Spencer's ideas for these and their intimate relationship with his beliefs about religion and sex. To refer at this point, as his biographers do with tawdry satisfaction, to the details of Spencer's two unstable marriages does not do justice to the ideas he formulated. 'In the flow of true imagination we know in full, mentally and physically at once, in a greater, enkindled awareness. At the maximum of our imagination we are religious.' The words might have been Spencer's, had he had such a gift for prose. In fact they were written by D. H. Lawrence in his *Introduction to These Paintings* of 1929. They serve to remind us that Spencer was not alone in his campaign for sexual freedom, and for its embodiment in a religion in which the teachings of Christ were purged of Pauline exegesis and Victorian piety. The revival of interest in Blake can be seen as another symptom of this movement, together with the efflorescence of erotic art between the wars. Eric Gill is just another example of a deeply religious artist in whose work occult and Christian symbolism are combined. Once again, without denying its individual character, Spencer's contribution should be set into the wider context.

Not that the context was wide enough for Spencer to make a living. His figure subjects of the later 'thirties, as was noted above, were the most personal and least accessible of all his work. They took him further along the path of self-expression and distortion than even his most loyal patrons were prepared to go. Edward Marsh was one of Spencer's earliest supporters. He liked both Blake and Lawrence, but his reaction to the *Beatitudes* (no. 35, 36) was not an unusual one. On the other hand, there appeared to be an unlimited demand for the landscapes which Spencer could produce with such facility. Inevitably, in the face of economic pressure to live by them, he began to denigrate them. Yet *Cottages at Burghclere* (no. 16) and *Cookham Moor* (no. 31) earn for Spencer a place of some distinction in the history of twentieth century landscape painting. It is worth recalling that Paul Nash was one of his contemporaries at the Slade, although Spencer's affinities as a landscape painter perhaps lie more with the younger brother, John Nash. All three joined the New English Art Club in 1919. As Sir John Rothenstein put it, 'where Paul would cherish the words of Sir Thomas Browne or Blake, John consults a seed-catalogue.' Spencer did both. His own word should not detract from the delicate naturalism of his landscapes and flower-pieces, in which the eye for detail which made him an uncannily sharp portrait painter informs and enlivens his portrayal of cottage gardens (no. 28) and local pasturage (no. 29). Moreover, his

love and control of the landscape were indispensable to his large-scale figure paintings. In *Love on the Moor* (no. 50) the ha-ha wall and the tufty lushness of the riverside meadow preserve the picture from dry theory, together with the ever-present and thankfully incidental detail; in contrast with the subject of the picture, there is nothing improbable about the urchins who play football in the background.

Similar fragments of the visual memory, recalled with undisguised pleasure, illuminate and enliven all Spencer's didactic works, if such a term is appropriate to the Port Glasgow Resurrections (no. 43, 44) for instance. Observed with the artist's eye for detail, they are represented with that sureness of touch which characterises the truly great painter. For in the last analysis, the quality of Spencer's paint comes through. He could be dismissive of the actual process; 'it does not whet my appetite to paint at all,' he confessed in a letter written to Hilda in October, 1957. Meticulous draughtsman that he was, the translation of his final designs into oils on vast canvases involved an expenditure of effort of which he became impatient. Yet fortunately the pictures themselves attest to his incorrigible skill, to his feeling for paint as a means of expression beyond the mechanics of technique. It is precisely because of this painterliness that a literary interpretation of Spencer's art is inadequate. No wonder he complained, 'don't try to make a boiled-down, simplified version of anything I say . . . the second-hand examples I have seen of myself I could not recognise.' His pictures are the first-hand evidence of Spencer the painter, of a man who deserves to be remembered not in his own words but in his own image, with a brush in his hand.

DUNCAN ROBINSON

Chronology

1891 Born 30 June at Cookham-on-Thames, Berks, the eighth surviving child of William Spencer, organist and piano teacher

1907 Entered Maidenhead Technical Institute

1908–12 Studied at the Slade School under Tonks; nicknamed 'Cookham' by his fellow students because he continued to live there, travelling up to London only for his classes. Awarded a scholarship, 1910; the Melville Nettleship Prize and the Composition Prize, 1912

1912 Exhibited *John Donne arriving in Heaven* and two drawings in Roger Fry's Second Post-Impressionist Exhibition at the Grafton Galleries

1915–18 Enlisted in the Royal Army Medical Corps and was posted to the Beaufort War Hospital, Bristol, July 1915. Sent to Macedonia in August 1916 and served with the 68th, 66th and 143rd Field Ambulances until August 1917, when he volunteered and joined the 7th battalion, the Royal Berkshires. Commissioned to paint an official war picture before his return to England in December 1918

1919 Lived and worked in Cookham. Member of the New English Art Club (until 1927)

1920–21 Went to live with the Slessers at Bourne End, near Cookham. Stayed at Durweston, Dorset, with Henry Lamb during the summer of 1920. Accepted an invitation from Muirhead Bone to Steep, near Petersfield, in the summer of 1921, and later took lodgings there

1922 Visited Jugoslavia with the Carlines during the summer. Moved to Hampstead in December

1923–24 Enrolled at the Slade for the spring term, 1923. Then stayed with Henry Lamb at Poole, Dorset, where Mr and Mrs J. L. Behrend saw his designs for the mural decoration of a chapel. Their decision to build the Memorial Chapel at Burghclere followed. Returned to Hampstead, October 1923, and used Henry Lamb's studio on the top floor of the Vale Hotel in the Vale of Health

1925 Married Anne Hilda Carline at Wangford, near Southwold. A daughter, Shirin, born

1926–27 Completed the *Resurrection* in 1926 and exhibited it in his first one-man show at the Goupil Gallery, February–March 1927. It was purchased by the Duveen Paintings Fund for presentation to the Tate Gallery. Moved to Burghclere to decorate the Memorial Chapel

1930 A second daughter, Unity, born

1932 Completed the Memorial Chapel and moved from Burghclere to Lindworth, Cookham. Elected ARA and had five paintings and five drawings shown at the Venice Biennale. In October, Dudley Tooth became his sole agent

1933 Invited to Switzerland by Edward Beddington-Behrens to paint landscapes; *Sarah Tubb* exhibited at the Carnegie Institute, Pittsburgh (honourable mention)

1935 Resigned from the Royal Academy after the rejection of *Lovers* and *St Francis and the Birds* by the hanging committee

1936 Visited Switzerland for a second time with the Beddington-Behrens

1937 Married Patricia Preece, 29 May. Spent a month in St Ives and also visited and painted at Southwold

1938 Twenty-two paintings shown at the Venice Biennale. Stayed with the Rothensteins and Malcolm McDonald until December, when he moved to a room in Constance Oliver's house at 188 Adelaide Road, London; began to paint the *Christ in the Wilderness* series

1939 Exhibited at J. Leger and Son in March–April. 30 July, moved to the White Hart Inn, Leonard Stanley, Gloucestershire with George and Daphne Charlton

1940 Commissioned to paint pictures of shipyards by the War Artists' Advisory Committee, and made the first of several visits to Lithgow's Yard, Port Glasgow

1941 Stayed with Mrs Harter, Sydney Carline's mother-in-law, at Epsom and continued to work on the Shipbuilders series

1942–44 Returned to Cookham, 7 January, as the tenant of his cousin, Bernard Smithers, with whom he stayed until May 1944. His visits to Port Glasgow continued, where he put up at the Glencairn boarding-house. Work continued on *Shipbuilders*. Began the *Resurrection* series with which he was pre-occupied until 1950. Often visited the Carlines and Hilda, then in Barnstead Hospital

1945 September, returned to Cookham, to Cliveden View

1947 Retrospective exhibition at Temple Newsam House, Leeds. The chapel at Burghclere was presented to the National Trust by Mr and Mrs J. L. Behrend

1950 CBE; rejoined the Royal Academy and elected RA. Hilda Spencer died in November

1952 Began preliminary drawings for *Christ Preaching at Cookham Regatta*

1954 Visited China as member of a cultural delegation

1955 November–December retrospective exhibition at the Tate Gallery

1958 Knighted, Hon D Litt, Southampton and Associate of the Royal College of Art. Exhibited at Cookham Church and Vicarage

1959 14 December 1959, died at the Canadian War Memorial Hospital, Cliveden

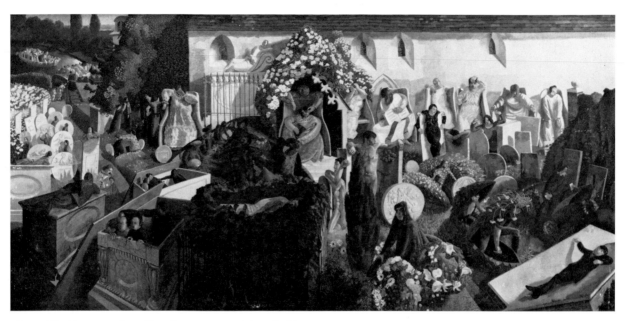

Fig. 1 The Resurrection, Cookham, 1926 *Tate Gallery*

Recollections of Stanley Spencer

Stanley Spencer, as I knew him, was never at a loss for words. When he had to break off from painting, he would often resort to writing as his other form of self-expression. He wrote endlessly, and has left us fully informed as to his motives in painting, his feelings about people in daily life or in fiction, or his reactions towards the things that concerned him.

It has to be remembered that he was extraordinarily well read, considering that his education was confined to lessons from his sisters Annie and Florence in the school room behind his home, Fernlea in Cookham High Street. From the age of sixteen, he read constantly from the classics, especial favourites being John Donne, Spenser's *Faery Queen*, *Paradise Lost*, and *Gulliver's Travels*; but he also found life-long enjoyment in Hans Andersen and in the Brer Rabbit stories, which he read in the penny Books for the Bairns.

But the Bible was his chief companion and source of inspiration and, from reading it so constantly, he unconsciously acquired something of a 'biblical style' in his writing. William Spencer, his father, organist and teacher of music, and his brothers, like himself, had something of the feel of Old Testament characters.

Most of his compositional paintings grew out of ideas, which were prompted by his reading of the Bible or other literature, but they were expressed in terms of his personal experience and set in familiar places. He imagined *The Nativity* (no. 2), which won for him the Slade School Summer Prize in 1912, as occurring in marsh meadows near Cookham, which, he wrote, 'leave me with an aching longing, and in my art that longing was among the first I sought to satisfy'. He added that the left-hand section of the picture celebrated his 'marriage to the Cookham wild flowers' by which he could share in Creation.

In subsequent years, he spoke disparagingly of his painting pure landscapes, which he did 'purely and solely for money'. It was his imagined subjects, which might have a landscape setting, that he regarded as his vital work. His *Zacharias and Elizabeth* of 1914,[1] with its wooded landscape, was set in the garden of St George's Lodge, and he recalled the gardener showing him how the leaves were drawn into the ground by the worms.

The places that mattered to him varied greatly. *The Centurion's Servant* of 1914,[2] showing Stanley himself, lying on an iron bedstead with others kneeling beside it, was based on his recollection of saying prayers in his bedroom. After his return from the War, he derived the idea for *Christ carrying the Cross* from seeing builders going past Fernlea with their ladders. *The Betrayal*, which he completed in Hampstead in 1923, was also visualised as happening outside Fernlea. 'I like to take my thoughts for a walk and marry them to some place in Cookham', he said.

The largest composition he had as yet made, and ultimately, perhaps, his most important, was the *Resurrection* (fig. 1) taking place in Cookham churchyard with the Thames in the distance. He painted it during several years, 1924 to 1926, using Henry Lamb's studio on the top floor of the Vale of Health Hotel on Hampstead Heath. The canvas stretched right across the room, and we had to squeeze our way past it, in order to get in or out of the studio. Stanley would be standing with palette and brushes on a pair of steps, painting a portion at a time, beginning at the top left-hand corner and working downwards. Most of the figures rising from their graves or the stone apostles on the church wall were derived from his friends. I posed in the nude for one of the figures and he did the same, using a mirror. He also painted me for a recumbent figure on a grave. My sister, Hilda, whom he married while the picture was under way, appears several times, smelling a flower and half enveloped in ivy on a tomb-stone.

Stanley's feeling for places was not confined to Cookham. For his series of pictures, for which Mr and Mrs Behrend built the Burghclere Chapel, he used ideas which were hatched, as it were, during his service in the First World War, and had long been fomenting in his imagination. Some were based on his

[1] Spencer wrote to Lamb on March 14th, 1914, that he had just begun work on this picture.

[2] A letter to Lamb of January 25th, 1915, states that he had already completed the picture which he began in October 1914.

experiences as an orderly in the RAMC at Beaufort Hospital, Bristol. 'I thought in agony', he wrote afterwards, 'how marvellously I could paint this moment in this corridor now, and if at any time this war ends I will paint it.' He loved the space between two baths, where he could scrub the floor unmolested. Thirteen years were to pass before he painted this subject together with the corridor, its floor covered with soapsuds. He worked on these nineteen paintings at Burghclere from 1927 to 1931.

His service in the War from July 1915 to December 1918, as a private soldier, involved much hardship throughout, but he felt no resentment for the discipline he had to endure. On the contrary, he rather enjoyed drill on the parade ground. A willingness to accept the confinement which military service involved was part of his philosophy. He indicated as much in his opening remarks to the students of the Ruskin School of Drawing at Oxford in 1922, his only spell of art teaching: 'The first place an artist should find himself is in prison. The moment he realises he is a prisoner, he is an artist, and the moment he is an artist, he starts to free himself.'

He never sought to evade his share of ordeal or danger. Indeed, in 1917, while serving in Macedonia, he asked for a transfer from the comparative security of the RAMC to the much more dangerous duties in an infantry regiment (the Royal Berkshire), partly because it would take him to a district which he had seen and liked; it provided the setting for his *Resurrection of Soldiers* on the end wall at Burghclere. He could accept the death of those who were close or related to him with stoicism.

Walls and fences always had a great fascination and he often used them to create a feeling of separation within a composition. He liked them because they led him to imagine what might lie on the other side. He felt the mystery there. 'Recently, at Cookham', he once told us, 'owing to the introduction of motor-buses, I was enabled to see over the top of many walls and found that what I saw was quite different from what I had expected. But what overjoyed me was that when I got down from the bus and walked along by the same wall, I found that I could still enjoy the feeling of wonder at what was on the other side'.

Stanley was never very particular over where he painted. While attending the Slade School from 1908 to 1912, he travelled each morning by train from Maidenhead to Paddington and got home to Cookham in time for tea. With six brothers and two sisters then living with his parents in their semi-detached house, he had to share a bedroom with several of the brothers. Stanley drew and even painted in his bedroom or in the dining-room, moving his work when the meal had to be laid. For painting *The Nativity* (no. 2), he found

room to work in the barn at Ovey's farm, opposite his house. When I first visited him in the Summer of 1915, taking my drawing-book to show him at his request, I found him painting in the attic of Mrs Hatch's cottage, with floor and racks strewn with apples and vegetables.

On returning from war service in December 1918, he was, of course, overjoyed to be back at home in Cookham, amidst places he revered and loved. But his three and a half years in huts or under canvas had left him restless. He found home conditions irksome and was easily irritated when the laundry was delivered with no-one but himself to open the front door, by persons going up and down stairs, by his father sneezing or losing a collar-stud. He was always liable to outbursts of temper. He was able to paint his *Travoys arriving with wounded soldiers at a dressing station in Macedonia* (no. 3) for the Imperial War Museum, during 1919, in Lambert's stables near his home. But chiefly it was the absence of sufficient heating, since warmth mattered to him more than food or drink, that compelled him to leave home.

Despite his devotion to Cookham, he quitted it for the next twelve years, though frequently returning for short visits. But during 1920 to 1921, he accepted the hospitality of Sir Henry and Lady Slesser at Bourne End, which was not far away across Cookham Bridge. Hilda and I paid him a visit there in 1920, and he met us on arrival carrying two small paintings, oil on paper, both of the piebald pony with the beehives down Mill Lane, giving one to each of us.

After painting *The Last Supper* (no. 6) at Cornerways, the Slessers' home, he had no settled abode for some years but continued to depend on the hospitality of friends or lived in lodgings as he did at Petersfield in 1922. It was at Poole, where he stayed with his close friend, Henry Lamb, that he evolved his designs from his war experiences, which he ultimately carried out in the Burghclere Chapel. He also made the preliminary sketches for the Cookham *Resurrection*. He used such sketches in pencil with sepia wash by squaring them up with a grid of lines, to help in transferring the preliminary composition on to the canvas. He was always determined to adhere faithfully to his original sketch and seldom deviated from it, when drawing the composition on the canvas before beginning to paint.

Stanley first came to visit my family in Hampstead in December, 1919, bringing Henry Lamb with him to dinner. This was the first of many visits, and in April he and his brother Gilbert joined us for a few weeks stay at Seaford. In the Summer of 1922, Stanley came with us for some months to Jugoslavia. For him, the great appeal was to be once again in a Turkish Moslem environment, such as he remembered in Macedonia. He longed to hear again, as we often

did, the Muezzin's melodious call from the minaret of the mosque, summoning the faithful to prayer.

It was in Sarajevo, capital of Bosnia, that he proposed to my sister, though their engagement was to be broken off almost as constantly as it was renewed. It was this expedition across Europe that enabled us to see the great collections of 'old masters' in Vienna and Munich, and these proved to be the only visits that Stanley ever made to any of the great museums abroad. Although a visit to Paris or Italy was then inexpensive, he never contemplated visiting the Louvre or seeing the masterpieces in Florence, Venice or Rome. Living in Hampstead gave him ample opportunity to go down to the National Gallery, but he did so only occasionally. His love of the Italian masters seemed to be satisfied by reproductions and he treasured the art books he received, notably one on Islamic Persian art. Even so, it was the shilling volumes published by Gowans and Gray, particularly those on Giotto and Masaccio, which were his special treasures.

Stanley often accompanied us, however, to the British Museum. Its ethnographical collection of African, Polynesian, Aztec and Inca sculptures interested me especially, and Stanley, equally, came to admire them, but his sympathetic nature often prompted such visits as a gesture of friendship. He was always ready with his support when I had a lecture to give on art. I recall that in 1924 a lectureship was vacant at the Wallace Collection and I was urged to apply. This entailed giving a conducted tour of the pictures, as a trial. Stanley resolved to set an example by following me around, well to the forefront and listening attentively. Unhappily, McColl, the Keeper, must have been aware of this, since he thoroughly embarrassed me by asking quizzically, if I knew the 'small, dark-haired young man, apparently some student from the Slade', who appeared to listen to me so keenly.

Some may well agree that his early work, culminating in the Cookham *Resurrection*, with the freshness and vigour of youth, constituted his greatest achievements; certainly, Stanley, himself, always felt he had lost something thereafter, which he tried hard to regain. On the other hand, the series on the walls at Burghclere must be pronounced his greatest 'tour-de-force'.

On completing his work at Burghclere, he bought Lindworth at Cookham, moving there with Hilda and their two young daughters, and my mother and I sometimes joined them. But domestic differences were manifest, for which Hilda must be apportioned her share of responsibility. Heated arguments were often prolonged far into the night. The strain caused her to absent herself, often for long periods, culminating in a divorce. Nevertheless, Stanley wrote to her regularly and he asked her, later, to re-marry him. He continued to address letters to her after her death in 1950. He maintained this devotion until his own death in the Canadian Hospital at Cookham nine years later.

RICHARD CARLINE

Richard Carline has recently completed a biographical study of Spencer's early life, together with his writings, to be published shortly by Faber and Faber.

Influences on the early work of Stanley Spencer

The visionary pictures of resurrection scenes for which Stanley Spencer is perhaps best known have too often led critics to portray him as a 'primitive' village painter. This is simply not true. He was both highly trained and professional, and his work bears the imprint not only of his study at the Slade but also of those other artistic influences which helped to mould it. His style indeed is less unusual than his subject-matter and, possibly because of this, it had an impact upon other English painters of his generation. Spencer was always ready to write about his art, and he was quite clear as to the artists and the writers who had most interested him.

He once said that all the important things that happened to him as a painter occurred before he went to the Slade. Certainly his early years at home and at Cookham were of crucial importance to him. He was in fact unusually dependent upon his family. His upbringing took place almost entirely at home. He was taught by two of his sisters in the Fernlea garden shed which served as a schoolroom for a number of local children. In the mid-fifties he commented, 'My elder sister said recently "You were not equipped" and how thankful she was when I began to get on with drawing.' The dominant interests in the home, literature, music and religion, were to remain Stanley's throughout his life. His father, William Spencer, was an organist and music teacher who also published his amateur poetry and studied astronomy in Lady Boston's observatory. He had a flair for finding patrons for his talented children and Lady Boston later paid Stanley's first fees at the Slade. William Spencer opened a free lending library stocked with Everyman volumes which the villagers never borrowed, and like so many Victorians, he frequently read aloud to his assembled family. Stanley's father was not the only musician in the family. Stanley's brother Will became a teacher at the Cologne conservatoire and most of the children learnt to play some instrument.

On Sundays, Father, Will, Harold and often Sydney too, had to be packed off to their organ lofts. Stanley himself was able to play Bach on the piano by ear. In 1929 he wrote to his wife Hilda that the '*big* Bach Organ Preludes & Fuges . . . are the most *convincing* religious expressions I know.'

As a child he attended the parish church as well as his mother's Wesleyan Methodist chapel. Both Stanley and his brother Gilbert were made to study their Bibles well. Their readings were ticked off on a card index supplied by the British and Foreign Bible Society of which their mother was the local secretary. As one sees in their paintings, they were able to visualize biblical events as taking place around them. Gilbert has written of Christmas, 'Stan and I could well imagine that the Shepherds watching their flocks would have been in the field below Cliveden Woods. That was the land of the Nativity for us.' When Stanley did paint the Nativity (no. 2) he set it in Cookham, although there is some disagreement as to its exact position in the village.

Spencer received his first painting lessons from a local artist and designer, Dorothy Bailey. But his chief contact with art was through books. This fact can be stressed, for in his own figure paintings the narrative and human aspects lie uppermost. Many of his childhood drawings were taken from the books and periodicals in Fernlea; a large number of these books are still in the possession of the family. He made drawings from *Pilgrim's Progress*, various sets of fairy tales, E. H. New's illustrations to Gilbert White's *A Natural History of Selborne*, *The Westminster Gazette*, Tenniel's cartoons in *Punch* and a Bible engraving of *Christ riding into Jerusalem* in Cassell's Children's Bible, published in 1883. The grotesque element which fascinated him in *Struwwelpeter*, in E. T. Read's *Punch* cartoons and in Arthur Rackham (he told Gilbert Spencer that he would like to be able to draw like Rackham) later made its way into his own work, as in his drawing entitled *Allegory* of 1910 and some of his figure paintings of the 1930s. The literary inspiration for *John Donne arriving in Heaven* (no. 1) of 1911 is given in the title itself.

Spencer lived in Cookham for much of his life, remaining at home while a student at the Slade. Through his work he has made the village as well known as Samuel Palmer's Shoreham or Constable's Dedham. His feeling for Cookham was intense, but in no sense parochial. Actually, he travelled more than is

often recognised. When he knew a place well, and usually this had to be for a prolonged period as with Macedonia and Glasgow in the two World Wars, it could inspire a whole new cycle of work.

After a year at the Maidenhead Technical Institute, spent largely in the academic practice of making drawings from plaster casts, Spencer entered the Slade School in 1908. He remained a student there for four years, winning a scholarship to cover the fees, and two important prizes. His fellow students included artists such as Paul Nash, Christopher Nevinson, William Roberts, Mark Gertler, David Bomberg and Sydney Carline. He emerged from the leading art school of the day as a young artist with a growing reputation. Slade students spent much time in drawing from the 'antique' and from 'life'. Their chief instructor was Professor Tonks, who was an inspired teacher of several generations of artists. Tonks' emphasis on the use of pencil for drawing and on the importance of form (clarified by light and shadow rather than by colour), as well as his interest in contemporary mural painting, made their impression on Stanley. Many of his later portrait drawings display a mastery of academic procedure and an unmistakable Slade character.

Slade students were expected to have some knowledge of the history of art, and Stanley's taste now grew to maturity. It remained fairly constant throughout his life. His favourite painters were undoubtedly the early Italians. This is confirmed not only by the style of his own work right into the 1920s and sometimes beyond, but by those who were close to him during this period. A whole 'gang' of fellow students, claiming Stanley as one of their number and calling themselves the 'Neo-Primitives', were equally enthusiastic. For the first time Stanley had the opportunity to study great works in the original and clearly he did so. Compare for instance the pattern of lances in Uccello's *Battle of San Romano* in the National Gallery, with that of the crosses in the Burghclere Chapel *Resurrection*. But, typically, he again found much of his inspiration in books. He often bought the little Gowans and Gray Art Books, priced at sixpence and containing about sixty monochrome plates. In 1948 Gilbert Spencer met Mr Gowans and told him: 'My brother Stanley owed his education to you.' Other people have said the same thing. In May 1946 Spencer wrote in a scrapbook, 'I still wish a Gowans and Gray little book could have been done. I once had some tiny photos of the Zacharias and John Donne pictures, and tried them on a page in an early Italian Gowans and Gray. I think it was a Fra Angelico. I wanted to see if it would satisfy me at all in the same way, and in many ways it was up to standard.' The similarities between Spencer and the early Italians are not hard to find. He used many of the same biblical themes: he painted nearly all the New Testament scenes used by Giotto in the Arena Chapel, Padua. Like the Italians, he set the scenes successfully in his own time and place, and concerned himself primarily with the human figure. Unlike many of his contemporaries, he was actually given the opportunity to decorate a chapel with mural paintings (the Burghclere Memorial Chapel) and in later years he planned another. He also experimented with a series of predella panels, for his picture of *The Betrayal*. Duccio, Giotto, Masaccio, Ghiberti, Donatello, Fra Angelico, Pisanello (he kept a reproduction by his bedside to see on awakening), Sassetta, Botticelli and Michelangelo were all especially meaningful to him, and he mentioned many of them in the letters which he wrote from Macedonia during the Great War.

In 1916 Spencer wrote from the Front to his friend Desmond Chute, 'I think John Ruskin, though such a bore and absolutely wrong, is a very fine man and fine writer and says some fine things. Anyhow I enjoy reading him, and rather wish I had some of his *Modern Painters*.' Four or five years earlier, he had been given Ruskin's essay *Giotto and his works in Padua* by his friends the Raverats. That it inspired him to paint *Joachim among the Shepherds* is well known. Ruskin said much which must have interested him, not only on Giotto (always one of his favourite painters) but on religious art in general. Ruskin describes Giotto's sacred subjects as filled 'with a prophetic power and mystery' but also with a 'natural homeliness and simplicity'. His angels are treated 'as though believing that angels might appear anywhere, any day, and to all men as a matter of course.' All this applies equally well to Spencer. In his Pentecost series for example, see *Sarah Tubb and the Heavenly Visitors* (no. 20) and *Separating Fighting Swans* (no. 19), his angels visit Cookham and perform various kindly acts. Nobody is startled by their presence. Ruskin called for a revival of religious painting in England, and Stanley Spencer took up the challenge.

Fra Angelico was also important to Spencer. Thus in *The Nativity* (no. 2) he treats the naturalistic details of the flowers, the grasses pressing up between the paving stones and the blossom on the tree with great attention. He does the same in *Zacharias and Elizabeth*, in which the figures are less rounded and their white garments fall gently around them. He brings out the meaning of his subject by emphasizing the relationship between the hands. In doing so he follows Fra Angelico's *Christ appearing to Mary Magadalene* in the Convent of San Marco in Florence, which appeared as a plate in the Gowans and Gray *Fra Angelico* volume.

In August 1916, Spencer made a note on the top of a letter: 'Keats, Blake, Coriolanus, Michelangelo, Velazquez, Claude, Early Flemish Painters. Drawing book. Box of Chocolate.' They were all necessary to him. The Gowans and Gray *Early Flemish Painters* illustrates *The Judgement Day* by Petrus Christus. It includes a motif popular with northern painters, namely the dead rising out of the ground at the Last Judgement. It recurs frequently in Spencer's resurrection pictures; for example, in *Resurrection: Raising of Jairus' Daughter* (no. 44). Brueghel too, with his simplified, rounded figures and his keen interest in human behaviour had particular appeal for Spencer. He once analysed Brueghel's *The Marriage Feast* for his brother Gilbert, pointing out numerous details, not so much about the style, as about the narrative content of the picture. This is one way in which his own work deserves to be interpreted. The Gowans and Gray book on Brueghel reproduces his *Christ carrying the Cross* in the Kunsthistorisches Museum, Vienna, where the figure of Christ is barely visible in the crowd. The same is true of Spencer's Christ in 1920; see the study for *Christ carrying the Cross* (no. 55).

According to Paul Nash, Selwyn Image was 'the last conspicuous Pre-Raphaelite before the second advent in the person of Stanley Spencer'. On this point at least, Spencer's early reviewers usually agreed. His contacts with Pre-Raphaelitism began in his childhood when reproductions of Rossetti's *Annunciation* and Millais' *Ophelia* hung on the walls at Fernlea. His brother Will also read Ruskin, and had even visited Holman Hunt in his studio. Spencer's copy of the Gowans and Gray *Rossetti*, inscribed 'Stanley Spencer 1913', remained amongst his possessions throughout his life. In 1913 he was also reading Rossetti's poetry. But once again Ruskin's ideas must have given him a lead. In *Giotto and his works in Padua* Ruskin makes this comparison: 'Giotto was to his contemporaries precisely what Millais is to his contemporaries. . . . The fourteenth century Giottesque movement and the nineteenth century Pre-Raphaelite movement are precisely similar in meaning – protests of vitality against mortality, spirit against letter, truth against tradition, and both . . . literally links in one unbroken chain of feeling.' After this, how could Spencer fail to identify himself with the Pre-Raphaelites? Not unnaturally, his own work is closest to theirs when the Pre-Raphaelites themselves were most loyal to the Primitives. There are clear links of style and feeling between *Zacharias and Elizabeth* and the Rossetti *Annunciation* which hung in Fernlea. It is tempting to believe that some of Spencer's fine, intricate, early pen and ink drawings, such as *The Fairy on the Waterlily Leaf* (no. 52), owe something in style to Pre-Raphaelite book illustration. 'If you couldn't be a native artist, you couldn't be one at all.' This has been a maxim with the Spencer brothers. Stanley Spencer has an inevitable place in a native tradition which embraces men like Blake, Palmer and Rossetti. They possess a visionary intensity, and they share a common background in the literature of Spenser, Bunyan and Milton.

In London the years immediately preceding the Great War were a time of excited activity, in which English artists and the public were introduced to a succession of modern styles. They were forced to come to terms with what had been happening in Paris. Spencer was not only aware of the ferment; he was, perhaps unintentionally, a part of it. Three of his works were chosen by Clive Bell for inclusion in Roger Fry's Second Post-Impressionist Exhibition at the Grafton Galleries in 1912. They were hung in the End Gallery with works by Cézanne, Bonnard, Matisse, Vlaminck, Picasso, Wyndham Lewis and Fry himself. What of Spencer's reaction to modern French painting? In July 1923 he wrote to his future wife Hilda Carline '(one) can't worship & revere Renoir or Cézanne, no doubt you think it is impossible to do that to any man, but I can do it to Bach & Giotto & Fra Angelico'. Spencer remained an independent artist, not joining any of the currently fashionable artistic groups. But on the other hand he has been grouped loosely with the English Post-Impressionists, and it does seem likely that the 'modern' elements in his style come from one branch of French Post-Impressionism. The *Apple Gatherers*, one of the most audacious of his pre-war compositions, is a good example of this style. Spencer has actually stated that in illustrating this Slade sketch subject he had no wish to produce something based directly on nature. Consequently he groups his figures in a decorative manner, disregards perspective and scale, emphasizes the hands by enlarging them, and stresses the all-over decorative unity of the canvas. Of the French Post-Impressionists, Gauguin had the most to offer Spencer. Not only was Gauguin interested in primitive art, he was also a painter of visionary religious subjects. Spencer had several opportunities to get to know his work. His friend Henry Lamb, who negotiated the sale of *Apple Gatherers* in November 1913, had spent two summers in Brittany where the legend of Gauguin was still strong. In the first of his two famous exhibitions, Manet and the Post-Impressionists of 1910, Roger Fry had shown over forty works by Gauguin. Tonks complained that all his students went to these modern exhibitions. The exhibition had included Gauguin's *Christ in the Garden of Olives* which is close to *Apple Gatherers* in both style and treatment.

Spencer left the Slade in 1912 and continued to live and paint at home. His brother Sydney's diary mentions their admiration for Michelangelo: in August 1911 they spent an evening looking at reproductions of Michelangelo drawings. They also studied Michelangelo's fresco of *The Last Judgement*, which fills the altar wall of the Sistine Chapel in the way that Spencer's *Resurrection of Soldiers* was to do at Burghclere. On 8 January 1913, Spencer began a pen and ink drawing of his brother's head. Sydney commented: 'He is very interested in his attempt and says Michelangelo's pen and ink work put him on to do it.'

The date 1923 marks a major division in Spencer's work. As he wrote in his introduction to his Tate Gallery retrospective in 1955; 'Before the 1914 war I had to be very convinced about a picture before I drew it or painted it. The drawing or painting of the thing was the experiencing of Heaven: it would have been unthinkable that I should or might find hitches or snags. The ability I might need in carrying out the work was dependent on there being no such a possibility. This state of sureness continues to about 1922–23, when I did the Betrayal. At this time I did the series of drawings for the Burghclere Memorial and also the drawing for the 1927 Resurrection. So that all the painting I was to do from 1922 to 1932 was settled in nearly every detail: ten years of solid bliss was ahead of me. But I knew in 1922–23 that I was changing or losing grip or something.'

CAROLYN LEDER

The Oratory of All Souls, Burghclere

When Spencer returned from active service in Macedonia at the end of the First World War, he did so with a commission to paint an official war picture. *Travoys arriving with wounded at a dressing station* (no. 3) was the result. However, it by no means exhausted Spencer's ambitions to commit to canvas, or to wall for that matter, his experiences of war. A number of oil-sketches survive, done in all probability close to the events depicted, of scenes of encampment (nos. 4 and 5). They, with others, were exhibited at the Goupil Gallery in 1927, dated in the catalogue 1919.

By 1923,[1] Spencer's ideas were maturing into an ambitious plan. In the summer of that year he was staying with the painter Henry Lamb at Poole, in Dorset. Lamb wrote to Richard Carline on 10th June, 'Stanley sits at a table all day evolving Salonica and Bristol war compositions.' That might have been the end of that, had Mr and Mrs J. L. Behrend not visited Lamb soon afterwards. On 19 July, Spencer wrote to Richard Carline's sister Hilda, his future wife, to tell her that the Behrends had greatly admired his war designs. Finally, on 16 September Spencer wrote with the news that they had decided to build a chapel to house his plans, near to their home in the Hampshire village of Burghclere. It would be in memory of Mrs Behrend's brother, Lieutenant Henry Willoughby Sandham, RASG, who died in 1919 from an illness contracted while serving in Macedonia. There was no doubt however that the initiative rested with Spencer. As J. L. Behrend commented, 'without Stanley, poor Hal would have had no memorial.'

Spencer's requirements for the chapel were simple but precise. What he wanted was reminiscent of the early fourteenth century Arena Chapel in Padua, decorated with frescoes by Giotto. Spencer had never been there, but he knew of it from Ruskin's book, *Giotto and his Works in Padua*, published by the Arundel Society in 1854. ('What ho, Giotto,' was, according to George Behrend, his immediate reaction

to the commission.) The divisions of the walls were his; the north and south bays both divided horizontally into central and lower zones beneath a continuous upper section, and an unbroken east wall. Detailed studies of the north and south walls are shown in the exhibition (nos. 56, 57). These, or similar ones, must have been given to the architect, Lionel Pearson, who designed the chapel and the adjacent almshouses. In doing so, he can have had very little personal scope, for Spencer's wishes dictated such detail as the dado, the width of the arches and the dimensions of each bay.

On 25 March 1927, the building was dedicated as the Oratory of All Souls by the Bishop of Guildford. Spencer moved down to Burghclere with his family. He had thought at first of painting the chapel in fresco, but practical difficulties led him to settle for

Fig. 2 Convoy arriving at hospital with wounded *Burghclere Chapel*

[1] The date is controversial; Behrend recalled the events described here as taking place a year earlier. I am indebted to Mr Richard Carline for quotation from dated correspondence.

the more familiar technique of oils on canvas. For the larger paintings, canvas had to be imported from Belgium to ensure adequate, seamless widths which were glued to the walls with an underlay of asbestos cloth. The smaller canvases were stretched in the conventional manner and fastened into the bays.

As the preliminary studies show, Spencer had decided upon the subject matter at an early stage. In the lower panels he planned to illustrate scenes of life at Beaufort War Hospital in Bristol, a former lunatic asylum, to which he had been posted in July 1915. To fill the main, arched-top bays, he designed three more hospital scenes and five of encampment in Macedonia. Spencer arrived at Burghclere with two of the canvases for the lower panels already painted. Once installed in the chapel, however, he adopted a methodical approach, beginning with the end bay of the north wall, nearest the entrance, on which he painted the *Convoy arriving at hospital with wounded* (fig. 2). The composition is, for him, typical. It is dominated by the gates of the hospital seen from that slightly-too-high viewpoint he favoured. They are painted being swung open, forcing diagonals into the picture just as the *Farm Gate* (no. 48) does, in a much later design.

The east wall, when he reached it, took almost a year to complete. The *Resurrection of the Soldiers* (fig. 3) provides the focal point of the cycle, both visually and spiritually. Spencer designed it, after some hesitation and a number of preliminary sketches in which the wall was broken up into several scenes, as a single, uninterrupted view, from a crowded, *trompe l'oeil* foreground of risen soldiers clustered around the altar to a distant landscape in which the figure of Christ collects the discarded crosses. The men themselves, especially those in the foreground, are individually characterised, as they rise and lift the burdens of their crosses. It is these, the simple, identical crosses of the military cemetery which dominate the scene with their stark illusionism. They are outstanding in the chapel as the symbols, the only visible instruments, of suffering and death. As Elizabeth Rothenstein wrote, 'at first (the soldiers) only handle them, exploring them unknowingly. He shows the growth of understanding in all its various stages until at last in the full light of revelation the soldiers know that in suffering and death they have triumphed, and they are shown embracing the crosses in ecstasy.'

Violence is significantly absent from the other scenes of war depicted in the chapel. Spencer's reminiscences of Macedonia concern reconnaissance, encampment, routine and relaxation. It has often been noted that *Map-reading* (fig. 4) on the south wall is the only scene directed by an officer. Spencer's war was in the ranks, and he commemorated his comrades-

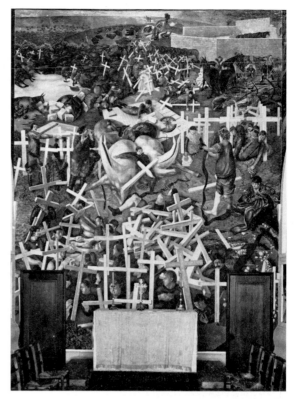

Fig. 3 The Resurrection of the Soldiers *Burghclere Chapel*

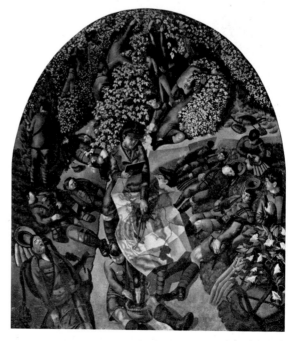

Fig. 4 Map-reading *Burghclere Chapel*

in-arms as he remembered them, off-duty or under the orders of their NCOs. In his treatment of them, the concern for detail is striking, and their close contact with the spectator, startling. Wilenski described the experience in 1933; 'by the artist's side . . . we smell the flesh of these herded soldiers, we feel the textures of their clothes and towels, the exact consistency of every object that they handle.'

Spencer worked at Burghclere until early in 1932, when he moved back to Cookham with his family. He painted the last two lower scenes for the south wall, *Bedmaking* and *Washing Lockers*, in the studio at Lindworth.

In 1947, Mr and Mrs Behrend gave the chapel with an endowment to the National Trust. It is open during reasonable daylight hours and a guide, pro-duced by the Friends of the Stanley Spencer Gallery, Cookham, is available.

DUNCAN ROBINSON

Literature: Richard Carline, 'New Mural Paintings by Stanley Spencer', *The Studio*, November 1928; R. H. Wilenski, *English Painting*, London, 1933, pp. 280–285, repr. plates 128a, 128b, 129, 130; E. Rothenstein, 1945, pp. 14–15, repr. plates 25–32; Newton, 1947, repr. plates 12, 14, 16, 18; J. Rothenstein, 1956, pp. 180–184, east wall repr. plate 17; E. Rothenstein, 1962, detail repr. in colour, plate 7; M. Collis, 1962, pp. 49, 76, 80, 90 ff., 98, 101 ff., repr. facing pp. 88, 89; George Behrend, *Stanley Spencer at Burghclere*, London, 1965.

The Sacred and the Profane in the Art of Stanley Spencer

'To me there are two joys the joys of innocence and religiousness and the joys of change and sexual experience and while these selves seem unrelated and irreconcilable still I am convinced of their ultimate union.' Thus Spencer wrote in 1940. The joys appear in all his work, in his early vision as well as in his later one, and the union of the spirit and the body was his life-long obsession.

Cookham and its inhabitants provided Spencer's early vision. His art was the expression of a direct experience of the presence of God in place and person. Cookham was the 'Village in Heaven'; in it lay the foundation of Spencer's faith in life and in himself. His early paintings are suffused with a sense of place and a deep feeling of peace. Spencer's childhood and adolescence was contained and innocent (though not without longings for the affections of the Wooster girls). The *Apple Gatherers* in a way presages the 'event of great moment' that was to shatter his calm.

Spencer welcomed his first sexual experience with the same open-hearted joy that had characterised his beatific vision of his home village; 'the first time I deliberately touched a woman here was a miracle I could perform.' Sexuality in his life was a great instrument of change. He recognised it was the means by which he was severed from his early self and writes of his meeting with Hilda Carline in 1921, 'from that day onward what I had always understood as being Stan Spencer was now no longer so – a whole heap of stuff lust or what you will was sweeping me along helpless.' War, too, shattered his innocence. The experience of death first-hand and deliberate made a lasting impression on Spencer. As a result of it, on his return to England from the fighting in Macedonia, he began to plan his first painting of *Resurrection*.

However, Spencer never lost his faith that Paradise could be realised in the present, and he believed that there was no part of his experience which could not contribute to that realisation. He writes, 'It has been my way to make things as far as I am able to – fit me so I did the Burghclere Memorial that operation redeemed my experience from what it was; namely something alien to me. By this means I recover my lost self.' In the Memorial Chapel, Spencer portrayed war as a path to redemption. His were not abstract notions of war, but the everyday doings of serving men, whether fastening their gaiters or scrubbing floors. Spencer's crosses are not burdens, but beacons to light the way. Burghclere is a personal profession of faith and an example of complete honesty to personal experience. Death he had conquered in the great Cookham *Resurrection* which he finished in 1927. In 1933, having finished the Chapel, he returned to Cookham after an absence of eleven years and tried to conquer sex.

'A deep feeling in me longs to be made whole and where the longings are felt most is in these sex feelings which are the very essence of what I love in myself.' From 1933 to the end of his life Spencer's imaginative works can be related to the vast scheme that was to show liberated sexuality as the path to salvation. He wanted to construct not a chapel, but a *Church-House*, to contain all the work which was to come under the title of *The Last Day*. The main theme of *The Last Day* was not Judgment but the Coming of the Apostles, who would bless and redeem the activities of the village by taking part in them. *Villagers and Saints*, which he started in the year he returned to Cookham, was the first work in the scheme. In 1937, the *Adoration of Old Men and Girls*, in which a disciple is 'helping the young men to make love', was completed. In the same year, he painted *Village in Heaven*, for which the area of Cookham around the War Memorial served as the setting. In the picture, the villagers indulge in a little natural amorousness, conducted by a disciple who stands as a 'love-creator' by the Memorial. In these paintings, Spencer united his old feeling for Cookham and its inhabitants with his conviction that liberated passion is 'the spiritual goal of humanity, for physical desire exists in human nature in order to aid understanding and add to the joy when it is reached.' He expressed the same belief on a universal scale in his painting of *Love among the Nations* of 1935, in which 'there is a girl adoring a negro's toes and an Englishwoman in ecstasy as she feels a Turk's cheek.' 'In life there is one art practised by all,' he wrote, 'and that is love.'

Love in its power to cross boundaries was the

theme of one section of the *Church-House*, for which Spencer planned but did not execute a painting of *Pentecost* as the centrepiece. Love in its relation to marriage provided a second theme in which *The Feast of Cana* was to symbolise the blessing of marriage by God. In connection with this subject, Spencer produced a series of *Couples*, paintings in which guests are represented either preparing to go to marriage feasts, as in *Choosing a Petticoat* or *Chest of Drawers* of 1936, or else returning from them and preparing to sleep, as in *Taking off a Collar* and *Going to Bed* of 1935. These paintings are autobiographical. In them, the artist recalled 'those happy homely moments' of his life with Hilda, his first wife, in the early years of their marriage. He did so with confessed nostalgia; 'my desire to paint pictures is caused by my being unable or incapable of fulfilling my desires in life itself.' The *Cana Couples* are the sublimation of Spencer's desire for a happy marriage and are, in many ways, a memorial of his life with Hilda. From them, he proceeded to paint another series of *Couples* for the *Church-House* in which he identified the characters more objectively. He spent a great deal of time writing biographies for these *Beatitude Couples*, for the cow-man and his wife, Sarah, for instance, in the picture called *Consciousness*. Gone from the canvas are references to interiors dear to him. He is interested only in making sure that each figure is the location of the other. Of *Passion* or *Desire* (no. 35), the first to be completed in 1936, he wrote, 'She is giving herself to him so that parts of her flesh become parts of his flesh every day.' For Spencer, the *Couples* in these paintings, in their complete love for each other, were perfect examples of marriage as a prayer to God. By giving each to the other and experiencing that union, they experienced something of the mystical union of God and the world. The *Beatitude Couples*, completed with *Worship* in 1938, were to be placed in special cubicles off the main aisle of the *Church-House*, where the visitor could meditate on 'Marriage as a Prayer to God.'

For Spencer, the Bible was the basis of his religious views. It gave both source and inspiration to a number of his most important early works. From them and from what followed, however, it must be clear that for Spencer orthodox Christianity had its limitations. It was while he was painting the *Beatitudes* that he wrote of Christ, 'in spite of trying to appear a condemner of authority he is always trying to uphold it and is one of the principal champions against individual intelligence and judgment.' Of Saint Paul, Spencer wrote, 'he is the originator of all that "get your hair cut" business that caused me so much trouble, he sounds like a Nazi to me.' In his search for a broader and more tolerant view of Christianity, it is not surprising that Spencer found the writings of William Blake to his liking. In Blake he found echoes of his own mystical experiences and a similar belief in the divinity of inspiration. In Blake too, Spencer's own pantheistic feelings seemed to find confirmation; 'the attractive thing about Blake is that God is found everywhere all the time,' he wrote in 1943.

Beyond Christianity, Spencer was drawn towards oriental religion and art. In his conception of the *Church-House*, he was influenced by the erotic sculptures of Kajuraho. In a letter to Hilda he wrote, 'I often think of us looking at the books on Indian sculpture, they seem to give me longings greater than those inspired by the Bible.' In these sculptures, the artist found a union of sexuality and nature in the portrayal of the tree-spirits or Asparsas for instance, which is reflected in *Sunflower and Dog Worship*. It was in oriental art that Spencer found also a powerful precedent for his belief that 'desire is the essence of all that is holy.' He had read Sir Edwin Arnold's *Light of Asia* at the Vale Studios, Hampstead, in the mid-twenties. Buddhism confirmed still further Spencer's instinctive pantheism and relieved him of the discomforts of dualistic morality. In Gautama he found himself reflected since he made 'everything part of the anything of him waiting to be born.' The *Church-House* never found a patron. Had it done so, it would have been nothing less than Spencer's declaration of faith in his own religion. In that religion, Christ and his apostles were seen as Eastern Avatars leading mankind to harmony and peace. Belief in such a Christ would lead to an understanding of 'life and the signification of things and we would come to the realisation that God is in everything and reach harmony ourselves.'

For Spencer, the years between 1933 and 1939 were fraught with personal difficulties. His ideal of a double marriage with Hilda and Patricia had been hopelessly quashed. The paintings of those years attempt to assimilate the disappointment. In 1939, he retired to a flat in Hampstead from which he scarcely emerged for three months. There he began the *Christ in the Wilderness* series (fig. 5), perhaps the most profoundly moving of all his religious pictures. They too make a deeply personal statement about his condition. Distanced from Cookham, he could become truly alone, and could compare the 'great adventure' of Christ, alone 'with the leaves and the trees and the rabbits' with his own isolation with two chairs, a bed, a fireplace and a table. 'I was, as it were, in a wilderness.' Spencer recognised that he had made a complete break with his previous work and perhaps in his portrayal of Christ as man tempted we see an admission of Spencer's own feeling of loss at not being able to contain completely his sexual desires. His stay

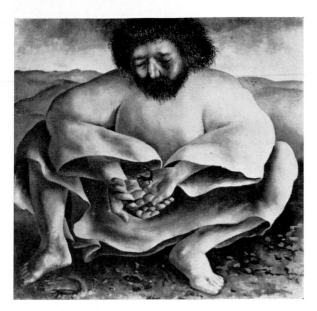

Fig. 5 Christ in the Wilderness **III**, The Scorpion, 1939 *Private Collection*

in the room confirmed his faith that the Kingdom of Heaven was in each man. He described a 'moment of wonder and joyful astonishment; . . . all is not only seen in a clearer and stronger light but this being so all that one is is seen to be not what one supposed but, so to speak, new and fresh and surprising and all these surprisings bringing one to further understanding. It is possibly what entering heaven will be like.'

The paintings show Christ in contemplation of his surroundings, a perfect relationship between man and the world and a reflection of Spencer's own feelings of equanimity; 'Christ is in the Wilderness and the Wilderness Himself.' Although Spencer does not use specific places in the pictures, he has returned to the feeling of earth as home. Like Spencer, his Christ was finding that 'the longer I stay in one place the nearer I get to life.' To the happiness he experienced at this point, Spencer looked back later with fondness. He recognised that *Christ in the Wilderness* had reunited him with God; 'I loved it all because it was all God and me, all the time.' The forty panels, of which he completed nine, were to decorate the ceiling of the chancel in the *Church-House*. With them, Spencer completed a cycle of seven years during which he attempted to celebrate in his art the opposing strains of his life. The final series implies a return to the spiritual but, as he said, 'there is no division or separation between any part of one's make-up and all of one's self is a vital part of any accomplishment or feeling.'

Spencer's life and work were an attempt to see 'the wholeness of things,' so that anything, properly considered, could be realised as 'a finger or knuckle of God.' Spencer saw himself as 'a new kind of Adam, and joy is the means by which I name things; that is, define my wishes through a knowing it as part of God.' In Spencer's vision, 'Love finds the articulation and the rhythm.' For 'the mystery of love is that it can find its abode in something not meant for itself, and yet when it does so, it is clearly its home.' His love for what others reject is the theme of *Dustman* or *Lovers* (no. 22), painted in 1934, for as Spencer wrote, 'I am always taking the stone that was rejected and making it the cornerstone in some painting of mine.'

ANTONY GORMLEY

Stanley Spencer: Shipbuilding on the Clyde, 1940–46

Shortly after the Second World War started, Dudley Tooth wrote to Sir Kenneth Clark, as he then was, asking if Spencer could be found a job as an Official War Artist: '. . . I am sure he will prove amenable to work with as he is terribly in debt all round . . .' Clark had been appointed Chairman of the recently formed War Artists' Advisory Committee, a body composed of a curious collection of artists, an art historian and civil servants representing the armed forces. This Committee, under the aegis of the Ministry of Information, was briefed to draw up a list of artists who might be employed to record the various aspects of the war for historical purposes, and to organise the execution of this scheme.

In March 1940, Spencer was interviewed by the secretary of the WAAC who noted '. . . He outlined a project that he had formed of painting a great picture of the Crucifixion with a predella which would contain scenes connected with the present war such as the over-running of Poland . . .' Spencer of course liked doing large scale projects and he now clearly wanted to do another Burghclere. The WAAC however had very meagre funds and at that time was reluctant to commit itself to paying for the vast scheme which Spencer had outlined. The question of subject matter was also important. As the WAAC was helping to compile an historical record, it was felt that only eye-witness accounts ought to be acceptable. A shipyard had been suggested as being a possibly fruitful subject and, as Spencer seemed quite interested in the idea, it was arranged that he would go to Lithgow's Shipyard in Port Glasgow to make sketches for one painting of a shipbuilding scene. He returned to London two weeks later, in an ebullient mood.

He had been delighted with the shipyard. From the earliest days in Cookham he had always felt most at ease living in small closely-knit societies of ordinary unpretentious people. That of Cookham itself, of course, was the one he knew and loved above all, but at various times he did become temporarily attached to other places. Although at first sight the shipyard in Port Glasgow was very different from the rural surroundings he had been used to, he found that within the yard a community had evolved very like the one he had known at home. Everyone was friendly and helpful and interested in what he was doing. The shipyard work itself appealed to him. Several of his previous pictures, such as Workmen in the House of 1935, showed craftsmen at work invested with an almost mystical aura, possessed of rare and arcane skills, inaccessible to others. Spencer's acute sensitivity to this effect is one of the main strengths of the Shipbuilding series. As is well known, conventional ideals of beauty had never meant much to him; and indeed, increasingly since the end of the First World War he had chosen and treated his subjects in an unconventional and sometimes startling way. The disturbing sexual pictures of the thirties are not the only manifestation of this; he relished almost any homely or squalid scene showing signs of human presence. So, where others might have seen in the shipyards only a grim impersonal chaos, Spencer saw friendly groups of men working at jobs on which all their skills were totally concentrated.

Having seen the yard and made dozens of sketches, Spencer's plan was to paint a whole frieze-like series of shipbuilding scenes, each section an autonomous composition showing a separate activity, yet introducing elements leading the eye on to the subjects of the adjacent sections. The whole series, including a large centre panel, would be extremely inconveniently shaped; 1 ft 8 in high by 73 ft long – though some sections were to be higher than that in places. The Committee gave cautious approval to the plan and agreed to pay for five or six canvases to begin with. Spencer, however, took it for granted that the entire scheme would eventually be carried out and set to work at once on the first part, the triptych Burners (no. 41). This shows a group of men cutting up sheets of steel with blowlamps, though 'group' is hardly the right word to describe the complicated composition of figures which Spencer painted. Each figure is conceived as an interlocking part of a pattern spreading over all three canvases. One's attention is focused on the centre section by the relative simplicity of the shapes, compared with the flanking sections where the contortion of the figures is exaggerated by the unnatural glare of the lamps.

After *Burners*, with which the WAAC was delighted, Spencer rapidly completed three more sections. By mid-1941 he had amassed a large number of drawings showing many different aspects of the shipyard. Some, such as a group of men sitting on a propeller eating their lunchtime sandwiches, were trivial in themselves, but Spencer was reluctant to discard them as they showed scenes so characteristic of life in the yard. He therefore decided to add, as a predella to the work, a row of long, narrow canvases running the whole length of the main series and directly below it. The predella would be composed of a panorama of all the little incidents that did not warrant treatment on the scale of *Burners* or *Riveters* or any of the other main sections. This arrangement would have the added advantage of making the proportions of the whole thing slightly less eccentric than before. When all the sections were hung the effective height would now be about five feet, the width remaining the same at about 73 feet.

Unfortunately the first nineteen foot section of the predella, *The Template*, was the only part that was done. By the time he had finished it and started on the next of the principal upper sections, Spencer's enthusiasm for the project had started to wane. He found that his original scheme had been conceived on too large a scale. He was now attracted by a vision of Port Glasgow which could not be incorporated into his shipbuilding series. Scenes peripheral to the work of the yards could be and were accommodated – *The Template* has a mother holding a baby and watching the work – but the religious themes to which he had been addicted all his life could not. This gradual turning away from the enclosed world of the shipyard eventually resulted in the Port Glasgow *Resurrection* pictures of 1945–50.

Meanwhile he still had nearly half of the *Shipbuilding* series to complete, although at this stage nobody had a very precise notion of how extensive the series would turn out to be.

The later canvases inevitably reflect Spencer's declining enthusiasm. Whereas all the sections up to *The Template* of 1941/2 are full of delightful incidents and shrewdly observed human touches, the later ones, especially *Plumbers* and *Riggers*, lack some of this vitality. Although superficially quite similar in appearance to the others, they rely for their effect either on their abstract formal qualities rather than on the significance with which the subject matter is imbued, or on a jumble of figures lacking the close observation and vigorous composition of the earlier ones.

Altogether Spencer completed eight sections of the series before the WAAC was wound up in 1946, and the final scheme was remarkably like that which he had outlined to the Committee in 1940. All the major sections on his original plan were completed together with several extra ones, although the main centre canvas, *Furnaces*, was much reduced in scale.

The *Shipbuilding on the Clyde* series was one of Spencer's largest undertakings, but it cannot really be judged as one integrated work in the way the Burghclere Chapel series can, where the *Resurrection* forms a single focus for the whole interdependent group. Although the effect of the *Shipbuilding* series is greatly enhanced if all the sections are seen together, with the exception of *The Template* they can each stand alone as self-contained pictures. This, despite the tendency, especially in the later sections, to give the impression that they could go on indefinitely if only Spencer had been able to keep unrolling a bit more canvas. The apparent self-sufficiency of the sections is, in a way, to their disadvantage. Because of the difficulty of finding the necessary space they are rarely seen together and when they are exhibited individually they are, of course, judged individually. When they *are* shown together, especially if hung in their proper sequence on one wall, they present a magnificent panorama which expresses, in Spencer's most sensitive manner, the many different facets of work in the Port Glasgow shipyards.

ROBIN JOHNSON

Exhibitions

The abbreviations are those used for references in the text

Goupil Gallery 1927
London, Goupil Gallery, '*The Resurrection*' and other works by Stanley Spencer, 1927

Tooth 1932 (*and subsequently*)
London, Messrs Arthur Tooth and Sons, who were Spencer's sole agent from 1932

Leicester Galleries 1942
London, Leicester Galleries, *Stanley Spencer Exhibition of Paintings and Drawings*, arranged by Ernest Brown & Phillips Ltd, in conjunction with Arthur Tooth & Sons Ltd., November 1942

Leeds 1947
Temple Newsam House, Leeds, *Paintings and Drawings by Stanley Spencer*, 25 July–7 September 1947

Arts Council 1954
The Arts Council of Great Britain, *Drawings by Stanley Spencer*, 1954. Introduction by David Sylvester

Tate 1955
London, Tate Gallery, *Stanley Spencer, A Retrospective Exhibition*, November–December 1955. Introduction by the artist

Arts Council 1961
The Arts Council of Great Britain, *Three Masters of Modern British Painting*, Second Series, touring exhibition, 1961

Worthing 1961
Worthing Art Gallery, *Sir Stanley Spencer*, RA, 1961

Cookham 1962 (*and subsequently*)
Cookham-on-Thames, King's Hall, *Stanley Spencer Gallery*, opened 7th April 1962, with an exhibition of works from the permanent collection, augmented by loans

Plymouth 1963
Plymouth, City Museum and Art Gallery, *Sir Stanley Spencer* CBE RA, 1963. Introduction by Richard Carline

Glasgow 1975
Glasgow, Scottish Arts Council, Third Eye Centre, Stanley Spencer, *War Artist on Clydeside, 1940–45*, 1975. Introduction by Joan Hughson

Selected bibliography

The abbreviations are those used for references in the text

RHW
R.H.W. (Wilenski), *Stanley Spencer*, Ernest Benn, London, 1924

E. Rothenstein, 1945
Elizabeth Rothenstein, *Stanley Spencer*, Phaidon Press, Oxford and London, 1945

Newton
Eric Newton, *Stanley Spencer*, The Penguin Modern Painters, Harmondsworth, 1947

Wilenski
R. H. Wilenski (Introduction), *Stanley Spencer: Resurrection Pictures 1945–50*, with notes by the artist, Faber & Faber, London, 1951

J. Rothenstein
John Rothenstein, *Modern English Painters, Lewis to Moore*, London, 1956

G. Spencer
Gilbert Spencer, *Stanley Spencer*, Gollancz, London, 1961

M. Collis
Maurice Collis, *Stanley Spencer*, Harvill Press, London, 1962

E. Rothenstein, 1962
Elizabeth Rothenstein, *Stanley Spencer*, Express Art Books, London, 1962

L. Collis
Louise Collis, *A private view of Stanley Spencer*, Heinemann, London, 1972

Lenders to the exhibition

Aberdeen
 Aberdeen Art Gallery 9, 43
Amsterdam
 Stedelijk Museum 33
Cambridge
 Fitzwilliam Museum 11, 15, 27, 34, 38, 39, 50, 85
Richard Carline Esq 10, 55, 59, 61–63, 65-67, 92, 93
Cookham
 The Stanley Spencer Gallery 6, 8, 36, 52, 56, 57
Miss Honor Frost 25
Thomas Gibson Fine Art Ltd 21
The Trustees of the Lynda Grier Collection 12, 14, 28
The Lord Hayter CBE 46
Mrs David Karmel 20
Leeds
 Leeds City Art Galleries 7, 19, 37
London
 The Arts Council of Great Britain 60
 The Imperial War Museum 3, 41, 86–89
 The Royal Academy of Arts 48, 51
 The Slade School of Fine Art, University College 2
 The Trustees of the Tate Gallery 23, 53, 58
Manchester
 City of Manchester Art Galleries 30, 31
Newcastle-upon-Tyne
 Laing Art Gallery, Tyne and Wear County Museums Service 22
Oxford
 The Ashmolean Museum 32, 64, 68
Private Collections 1, 4, 5, 16, 17, 26, 40, 69–84, 95
Rochdale
 Rochdale Art Gallery 29
Sir John and Lady Rothenstein 54, 91
Rugby
 Rugby Borough Council 13
The Executors of the late G. G. Shiel 45
Southampton
 Southampton Art Gallery 18, 44, 90
Miss Shirin Spencer 94
Swansea
 Glynn Vivian Art Gallery and Museum 49
Professor and Mrs N. B. B. Symons 47
Lord and Lady Walston 24, 35, 42

Catalogue

Paintings

1 John Donne arriving in Heaven **1911**
Oil on canvas, 14½ × 16 in
Signed, with the brush, *verso*, 'S Spencer/1911/
Cookham'

Provenance: Purchased from the artist by Gwen
Raverat (née Darwin), 1911

Exhibited: London, Grafton Galleries, *Second Post-
Impressionist Exhibition*, 1912 (149) and 1913 (175);
Goupil Gallery, 1927 (58); Leger Gallery, 1939 (13);
Tate Gallery, 1955 (2); on loan to Exeter Museum
and Art Gallery since 1974

Literature: RHW, 1924, p. 11, repr. plate 12;
C. Johnson, *English painting from the seventh century
to the present day*, London 1932, p. 328; G. Spencer,
1961, p. 110; M. Collis, 1962, p. 243

Jacques and Gwen Raverat were fellow students of
Spencer at the Slade. They gave him a copy of John
Donne's *Sermons* from which the inspiration for this
picture came. 'He told me,' his brother Gilbert wrote,
'he had the idea that heaven was to one side: walking
along the road he turned his head and looked into
Heaven, in this case a part of Widbrook Common'.

Lent anonymously

2 The Nativity **1912**
Oil on canvas, 40½ × 60 in

Provenance: Awarded the Nettleship prize for figure
painting at the Slade School of Fine Arts, 1912, and
so became the property of University College, London

Exhibited: London, Tate Gallery, on loan 1921–22;
New English Art Club, *71st Retrospective Exhibition*,
1925 (102); Manchester, NEAC *Retrospective
Exhibition*, 1925 (140); Vienna Secession, *Meister-
werke englischen Malerei aus drei Jahrhunderten*, 1927
(344); Amsterdam, Stedelijk Museum, *Twee Eeuwen
Engelse Kunst*, 1936 (142), repr.; Venice, *Biennale*,
1938 (72); New York World's Fair, *Contemporary
British Art*, 1939 (131); and British Council
Canadian Tour, 1939–40 (131), and USA Tour, 1942
(94); Leeds, 1947 (1) repr.; British Council, South
Africa, *Contemporary British Paintings and Drawings*,
1947 (105); Birmingham City Art Gallery, *Modern
Painters*, 1949; Bristol, Festival Exhibition, 1951;
Tate Gallery, 1955 (3); British Council, Oslo and
Copenhagen, *Contemporary British Art*, 1956;
Aberdeen Art Gallery and Industrial Museum, 1957;
British Council, New York, *Masters of British
Painting 1800–1950*, 1957; Plymouth, 1963 (2); Arts
Council, Welsh Committee, *Stanley Spencer:
Religious Paintings*, 1965; London, Royal Academy,
The Slade 1871–1971, 1971 (22)

Literature: RHW, 1924, repr. plate 3; *Apollo* III,
1926, p. 5, repr.; C. Johnson, *English Painting from
the Seventh Century to the Present Day*, London 1932,
p. 331; *The Studio*, no. 125, 1943, p. 50; E.
Rothenstein, 1945, repr. plate 2; G. Charlton, 'The
Slade School of Fine Art', *The Studio*, October 1946,
p. 8, repr.; J. T. Soby, *Contemporary Painters*,
New York (Museum of Modern Art) 1948, p. 123;
E. Rothenstein, 1962, p. 2, repr. plate 1; M. Collis,
1962, pp. 39, 41, 69, 243

The picture was painted in a barn at Ovey's Farm,
Cookham, and taken up to London by Spencer for
assessment at the Slade. Recognised at once as an
outstanding achievement it is, with the *Apple
Gatherers* (Tate Gallery), his most important early
work. 'He has shown signs' wrote Tonks, 'of having
the most original mind of anyone we have had at the
Slade and he combines this with great powers of
draughtsmanship.' As Carolyn Leder points out (v.s.),
Spencer also displayed a variety of artistic interests in
this picture, in early Italian painting, in Gauguin and
the Post-Impressionists and, like them, in primitive
art. In doing so, he shared the outlook of his fellow-
students at the Slade where he was perhaps less
isolated than his nick-name, 'Cookham', implies.

*Lent by the Slade School of Fine Art, University
College, London*

3 Travoys arriving with wounded at dressing-station **1919**
Oil on canvas, 72 × 86 in

Provenance: Commissioned as an official war painting by the Ministry of Information, and acquired for the national collection, 1919

Exhibited: London, Royal Academy, *The Imperial War Museum, The Nation's War Paintings*, 1919–20 (75); Manchester City Art Gallery, 1920 (120); Tate Gallery, on loan 1921–24; Society of Scottish Artists 1930–31; Tate Gallery, 1955 (14); Arts Council 1961 (24); Plymouth 1963 (6)

Literature: RHW, 1924, pp. 19–20, repr. plate 11; J. Rothenstein, *English Artists and the War*, London 1931, repr. plate LXII; C. Johnson, *English Painting from the Seventh Century to the Present Day*, London 1932, pp. 330; M. Chamot, *Modern Painting in England*, London 1937, pp. 74–75; *Studio*, 118, 1939, repr. p. 229; Newton 1947, repr. plate 8; J. T. Soby, *Contemporary Painters*, New York, 1948, pp. 125–126

Spencer painted this picture for the Ministry of Information in Lambert's Stables, Cookham. It is based upon his experience of active service in Macedonia, and records the scenes at a dressing station immediately after the attack of the 22nd Division on Machine Gun Hill in the Doiran-Vardar sector of the battle-field, during September 1916. The wounded were transported through the mountains by means of the mule-drawn stretchers depicted here. In his later, unfinished, autobiography Spencer recalled, 'One night when I was at Smol near the little Greek church used this night as an operating theatre. It was a memory of this that I had when I did the *Travoys* . . .' He received the commission to paint the picture while still on active service; a first study for it was lost at the battle-front in 1918.

Lent by the Imperial War Museum

4 Making a red cross **1919**
Oil on millboard, 7 × 9 in

Provenance: From the collection of Mrs Gwen Raverat

Exhibited: Goupil Gallery, 1927 (64)

This small oil-sketch, like the following one of *Scrubbing clothes*, describes the activities of soldiers on the Macedonian front. Here a group of men work to lay a red cross of mercy out of coloured stones. The episode appears with very few changes in the Burghclere Chapel paintings, as part of the *Riverbed at*

Todorovo, the decoration of the upper register of the south wall in which soldiers are shown performing a wide range of off-duty tasks. Spencer presumably painted the oil-sketch soon after the event, and in all probability well before his ideas for a chapel began to take precise shape.

Lent anonymously

5 Scrubbing clothes **1919**
Oil on millboard, 7 × 9 in

Provenance: From the collection of Mrs Gwen Raverat

Exhibited: Goupil Gallery, 1927 (66)

Like the previous oil-sketch, this one records a scene with which Spencer was familiar during his service in Macedonia. The subject of soldiers scrubbing their clothes on the rocks in the river-bed features prominently in the Todorovo scenes in the Burghclere Chapel, but is far more specific in detail there than in the more distant view captured by this sketch.

Lent anonymously

6 The Last Supper **1920**
Oil on canvas, 36 × 48 in

Provenance: Purchased from the artist by Sir Henry Slesser, 1921; sold to J. L. Behrend, 1940; purchased after an appeal and with a contribution from a Fund set up by Cookham Church, by the Trustees of the Stanley Spencer Gallery, Cookham

Exhibited: London, New English Art Club, *64th Exhibition*, 1921 (3); Leger Gallery, 22 March–22 April 1939 (15); National Gallery, *British Painting since Whistler*, 1940 (150); Tate Gallery, Contemporary Art Society, *The Private Collector*, 1950 (256); Tate Gallery, 1955 (18); Cookham, 1962 and subsequently; Cardiff, Llandaff Cathedral, *Stanley Spencer–Religious Paintings*, 1965; in recent years the picture has hung permanently in Cookham Church

Literature: RHW 1924, repr. plate 14; E. Rothenstein, 1945, repr. plates 15–17; Newton, 1947, repr. plate 5; *The Studio*, 119, 1940, p. 185, repr.; M. Collis, 1962, pp. 69–70, 243; Stanley Spencer Gallery, *Catalogue and Annual Report*, No. 2, 1963–4, repr. on cover

In 1920, Spencer escaped from the cramped conditions of the family's home at Fernlea by accepting an invitation from Henry Slesser (later Lord Justice Slesser) to stay at his house at Bourne End, only a few miles away from Cookham on the other side of the

River Thames, in Buckinghamshire. Together with the painting of *Christ Carrying the Cross* (Tate Gallery), the *Last Supper* must be the most important of the works Spencer painted at the Slessers'. The composition is based upon a drawing made in 1915; the setting is a malt-house, in which Spencer enjoyed a feeling of seclusion and the particular quality of light produced by its low windows.

Lent by the Stanley Spencer Gallery, Cookham

7 **Christ's entry into Jersualem** *c.* **1920**
 Oil on canvas, 45 × 57 in

Provenance: Leeds City Art Galleries, before 1942

Exhibited: Leeds, 1947 (14), as *c.* 1925; Arts Council, *Decade 1920-30*, touring exhibition 1970 (135), repr.

Presumably another of the New Testament subjects painted by Spencer at Bourne End in 1920, this picture may be compared with *Christ Carrying the Cross* (Tate Gallery). The figures who start out of the bushes as Christ rides past are reminiscent of those peering from windows at the procession to Calvary. In both pictures, the precise red-brickwork of the buildings crowd the action into the foreground and the figures themselves are simplified and weightless.
 A study in pencil and wash for the painting was exhibited at the Leicester Galleries, 1942 (45).

Lent by the Leeds City Art Galleries

8 **Christ overturning the money-changers'
 tables** **1921**
 Oil on canvas, 29½ × 23½ in

Provenance: Presented to the Stanley Spencer Gallery, Cookham, by Mrs E. M. Tooth, in memory of her husband, the late Mr Dudley Tooth, 1972

The painting illustrates the Gospel of St Matthew, Chapter 21, verse 12; 'And Jesus went into the temple of God, and cast out all them that sold and bought in the temple, and overthrew the tables of the money-changers, and the seats of them that sold doves.' It is another of the New Testament subjects painted by Spencer at the Slessers', where he produced in the course of several months, twenty canvases. This one is closely comparable to *St Veronica unmasking Christ*, also presented to the Stanley Spencer Gallery by Mrs Dudley Tooth in 1972. In both the artist paints figures as simplified, block-like forms, which recall his treatment of *John Donne arriving in Heaven* (no. 1).

Lent by the Stanley Spencer Gallery, Cookham

9 **Crucifixion** *c.* **1922**
 Oil on paper, mounted on canvas, 26¼ × 42½ in

Provenance: Purchased by Aberdeen Art Gallery from the Leger Gallery, 1938

Exhibited: Reading, *Christian Arts Festival*, 1950 (29); Edinburgh, Royal Scottish Academy, 1952 (286); Tate Gallery, 1955 (23); Arts Council, 1961 (26); Plymouth, 1963 (9); Arts Council, Welsh Committee, *Stanley Spencer: Religious Paintings*, 1965; Arts Council, *Decade 1920-30*, touring exhibition 1970 (131)

Spencer painted the picture in his lodgings at Petersfield in 1922. The landscape was inspired by a view he remembered seeing in Macedonia during the war.

Lent by the Aberdeen Art Gallery

10 **Looking towards Cookham Bridge** **1921**
 Oil on board, 10 × 13⅞ in

Provenance: In the artist's possession at the time of his death; purchased by Richard Carline through Messrs Arthur Tooth and Sons, 1960

Exhibited: London, Leicester Galleries, *Artists as Collectors*, 1963; South London Art Gallery, *Paintings 1914-1924*, 1974

According to Richard Carline, this was the only oil in Spencer's possession when he died. He may have kept it for sentimental reasons; it is at all events one of his earliest landscapes, probably painted while he was with the Slessers at Bourne End in 1921.

Lent by Richard Carline, Esq

11 **Sarajevo, Bosnia** **1922**
 Oil on canvas, 24 × 22 in

Provenance: Given to the Fitzwilliam Museum by Mrs Frederick Leverton Harris, 1928

Spencer went to Jugoslavia in the summer of 1922 with the Carlines, on a painting expedition. The landscape, together with the Moslem culture of Bosnia, reminded him of Macedonia and his wartime experiences there. He painted ten landscapes in all, sometimes setting up his easel beside those of his friends.

Lent by the Fitzwilliam Museum, Cambridge

12 Still-life 1923

Oil on canvas, $13\frac{1}{4} \times 17\frac{1}{4}$ in

Provenance: Dr Lynda Grier

Lent by the Trustees of the Lynda Grier Collection

13 Portrait of Richard Carline 1923

Oil on canvas, $21\frac{1}{2} \times 15\frac{1}{2}$ in

Provenance: Bought by Edward Marsh, who bequeathed the picture to the Contemporary Art Society; presented to the Rugby Art Gallery

Exhibited: London, Goupil Gallery Salon, 1925; Leeds, 1947 (11); London, Gallery Edward Harvane, *Hampstead One*, 1973 (1); Cookham, Odney Club, *The Spencers and the Carlines in Hampstead in the 1920s*, 1973 (3); Liverpool, Bluecoat Gallery, *An Honest Patron* (Sir Edward Marsh), 1976

Spencer painted this portrait of his future brother-in-law in Henry Lamb's studio at the Vale Hotel in 1923.

Lent by the Rugby Borough Council

14 Landscape near Wangford 1925

Oil on canvas, $9\frac{3}{4} \times 11\frac{1}{2}$ in

Provenance: Dr Lynda Grier

Exhibited: Cookham, Odney Club, *The Spencers and the Carlines in Hampstead in the 1920s*, 1973 (4)

Spencer married Hilda Carline in Wangford Parish Church in February 1925. They spent a prolonged honeymoon in the same village, near to Southwold in Suffolk, where they lodged with Mrs Lambert. Gilbert Spencer joined them there, and recalled, in 1961: 'We stayed in a cowman's cottage and painted out of doors ... In the evenings we would sit around, Stan as usual at a corner of the table either reading or looking at reproductions.' Or drawing, for that matter; see Spencer's portrait of his brother, no. 59.

Lent by the Trustees of the Lynda Grier Collection

15 Building a church *c.* 1930

Pencil, wash and oils on paper, arched top, 12×21 in

Provenance: From the collection of Mrs Gwen Raverat

It is difficult to date the oil-sketch precisely, but the general disposition of the figures in a shallow but crowded space against the background of the church recalls the *Resurrection* of 1927. Details of the composition appear in independent works; the men carrying brick-hods on the left anticipate the figures in *Builders* of 1935 and the right-hand detail of men cutting columns is repeated more exactly in *Making Columns for the Church* (no. 26). These repetitions do not preclude an earlier date, however, in view of Spencer's habitual retrospection.

Lent anonymously

16 Cottages at Burghclere *c.* 1929

Oil on canvas, $24\frac{1}{2} \times 63$ in

Provenance: Purchased by the Friends of the Fitzwilliam Museum, 1930

Exhibited: London, Goupil Gallery, *Goupil Gallery Salon*, 1930 (56); Tate Gallery, 1955 (27); Cookham, 1969; Cambridge, Kettle's Yard Gallery, *Opening Exhibition*, 1970 (20)

Literature: Friends of the Fitzwilliam Museum, *Annual Report*, 1930, repr.; *The Studio*, special spring number, 1931, repr. p. 92; F. Rutter, *Modern Masterpieces*, I, London, 1935, repr. p. 11; M. Chamot, *Modern Painting in England*, London, 1937, p. 76, repr. plate vii

The Spencers moved to Burghclere on 5 May 1927, first to a farmhouse called Palmers Hill and then, in February 1928, to Chapel View, the cottage built for them by the Behrends as a home while Spencer worked on the Memorial Chapel. Until 1932 the decoration of the chapel absorbed the greater part of his attention, although he found time to paint the occasional landscape, as this canvas attests.

Lent by the Fitzwilliam Museum, Cambridge

17 The May-tree 1932

Oil on canvas, 34×54 in

Provenance: Private collection

Exhibited: Cookham, Stanley Spencer Gallery, 1963 and subsequently

Literature: Newton, 1947, repr. plate 20; E. Rothenstein, 1945, repr. plate 43 (colour)

Lent anonymously

18 Portrait of Patricia Preece **1933**
Oil on canvas, 33 × 29 in

Provenance: Purchased by J. L. Behrend from the artist through Messrs Arthur Tooth and Sons, 1934; lent to Southampton Art Gallery, 1950–55 and purchased from Mrs J. L. Behrend by the Gallery, through the Smith Bequest Fund, 1954

Exhibitions: London, Royal Academy, *Summer Exhibition*, 1934 (688); British Institute of Adult Education, touring exhibition, *A Loan Exhibition of Paintings and Drawings*, 1935–36; Southampton Art Gallery, *Opening Exhibition*, 1939 (50); Tate Gallery, 1955 (28); Barnsley, Cannon Hall, *Four Modern Masters*, 1959 (25); Worthing, 1961 (10); Plymouth, 1963 (19); Le Havre, Musée des Beaux-Arts, *Peintres Anglais*, 1975 (26)

Literature: Newton, 1947, repr. plate 23 (colour); Aldous Huxley, *Point Counter Point*, Penguin Books, Harmondsworth, 1968, repr. on cover; L. Collis, 1972, repr. facing p. 24

Patricia Preece was born in 1900. She studied at the Slade under Tonks and in Paris with André Lhote, before settling in the 'twenties at Moor Thatch, a cottage near to the War Memorial on the edge of Cookham Moor, which belonged to her friend Dorothy Hepworth. Spencer met her in a teashop in Cookham in 1929.He saw her regularly during his visits to Cookham in 1930 and 1931. By the time the Spencers moved into Lindworth in 1932 the future course of events was plain. Patricia Preece inspired a great deal of Spencer's finest work of the 1930s, before she became the second Mrs Spencer in 1937. The marriage did not survive the honeymoon in St Ives; Spencer returned alone to Lindworth, his wife and Miss Hepworth to Moor Thatch. Lady Spencer died in 1971.

Lent by the Southampton Art Gallery

19 Separating Fighting Swans **1932–33**
Oil on canvas, 36 × 28½ in

Provenance: Purchased for the Leeds City Art Galleries from the artist through Messrs Arthur Tooth and Sons, 1933

Exhibited: Tooth, 1933 (22); Leeds, 1947 (24); Arts Council of Great Britain, *British Contemporary Paintings from Northern Galleries*, 1952 (14); Tate Gallery 1955 (30); Arts Council 1961 (29); Plymouth 1963 (17)

Literature: E. Rothenstein, 1945, repr. plate 37; Newton, 1947, repr. plate 24; *Leeds Art Calendar*, vol. 2, no. 8, 1949, p. 12, repr. (colour); G. Spencer, 1961, pp. 184–5; E. Rothenstein, 1962, repr.; L. Collis, 1972, repr. facing p. 72

The swans at Cookham featured more than once in Spencer's painting; in 1914 he began the painting of *Swan Upping* which he completed after the war in 1919, and which now hangs in the Tate Gallery. Apparently he had ventured to separate fighting swans on the river some time before 1932. In this picture, Patricia Preece looks on and three angels witness the deed. It is one of a series of paintings Spencer intended for a Cookham Chapel along the lines of Burghclere, in which the place and its inhabitants would, in their everyday actions, become the agents of divine revelation. 'All the figure pictures done after 1932' he wrote in 1955, 'were a part of some scheme the whole of which scheme, when completed, would have given the part the meaning I know it had.'

Lent by the Leeds City Art Galleries

20 Sarah Tubb and the Heavenly Visitors 1933
Oil on canvas, 37 × 41 in

Provenance: Purchased from the artist through Messrs Arthur Tooth and Sons, 1934

Exhibited: Tooth, 1933 (21); Pittsburgh, Carnegie Institute, *International Exhibition of Painting*, 1933 (133), repr. plate 7; Sheffield, Graves Art Gallery, *Twentieth Century British Painting*, 1936 (8); Leicester Galleries, 1942 (17); Tate Gallery, 1955 (29); Arts Council of Great Britain, touring exhibition, *Three Masters of Modern British Painting*, 1961 (30); Plymouth, 1963 (18)

Literature: E. Rothenstein, 1945, repr. plate 35; Newton, 1947, repr. plate 13 (colour); *The Studio*, 125, 1943, p. 60, repr.; G. Spencer, 1961, pp. 184–5; E. Rothenstein, 1962, repr.

Another of the pictures designed for a Cookham Chapel. In this painting Spencer commemorates Sarah Tubb, an old Cookham inhabitant, who prayed in the street because she was frightened of Halley's Comet. He imagined her being comforted and rewarded by the heavenly visitors.

Lent by Mrs David Karmel

21 Souvenir of Switzerland **1934**

Oil on canvas. Triptych, centre panel $41\frac{1}{4} \times 66$ in,
side panels each $41\frac{3}{4} \times 30$ in

Provenance: Commissioned by Sir Edward Beddington-Behrens; private collection; Thomas Gibson, Esq

Exhibition: British Council, touring exhibition to USA, *British Contemporary Art*, 1946–47; on loan to the Tate Gallery

Literature: E. Rothenstein, 1945, repr. plate 38 (detail); M. Collis, 1962, pp. 105–6, 113, 244; Sir Edward Beddington-Behrens, *Look Back, Look Forward*, London 1963, pp. 92–98, repr. detail; L. Collis, 1972, pp. 50–51

In 1933, Beddington-Behrens invited Spencer to Saas-Fee in the Swiss Alps, 'the beautiful old village where I was staying 7,000 feet up, just below the glaciers', he wrote. 'At that time it could only be reached by a steep, stony track, and in fact mules were the chief means of transport. To see Stanley on mule-back was a really comic sight. Imagine a dark-complexioned little man about four feet ten inches in height, dressed like a tramp with a dirty hat set at an impossible angle, perched on a mule . . .'. At Spencer's suggestion Beddington-Behrens arranged for Patricia Preece to join them before he left for England. Apart from painting the landscape, Spencer executed, on his return, this *Souvenir of Switzerland*, which is based upon drawings and memories of Saas-Fee.

Lent by Thomas Gibson Fine Art Ltd

22 The Dustman or the Lovers **1934**

Oil on canvas, $45\frac{1}{4} \times 48\frac{1}{4}$ in

Provenance: In the artist's possession, 1945; with Messrs Arthur Tooth and Sons, from whom purchased by the Laing Art Gallery in 1948

Exhibitions: Newcastle-upon-Tyne, Laing Art Gallery, *The C. Bernard Stevenson Memorial Exhibition*, 1957 (194) repr.; Cookham, 1966

Literature: E. Rothenstein, 1945, repr. plate 39; Laing Art Gallery, Newcastle-upon-Tyne, *The Creation of an Art Gallery*, n.d. (1956), repr. (n.p.); M. Collis, 1962, pp. 114, 117, 138, 244; L. Collis, 1972, pp. 57, 64, 75, repr. facing p. 41

The picture was rejected, along with *St Francis and the Birds*, by the hanging committee of the Royal Academy in 1935 (see no. 23). Superficially one of Spencer's more eccentric works, he described it as 'the glorifying and magnifying of a dustman. His wife carries him in her arms and experiences the bliss of union which his corduroy trousers quicken'. The relationship of the couple, with the woman cuddling the dustman like an overgrown babe in arms, antici-pates several of the *Beatitudes* Couples of 1937–38. In Spencer's fascination with rubbish, some have seen only perversity, but as Antony Gormley argues above, the redemption of what others discard was an important sentence of his Creed.

Lent by the Laing Art Gallery, Newcastle-upon-Tyne (Tyne and Wear County Museums Service)

23 St Francis and the Birds **1935**

Oil on canvas, 26×23 in

Provenance: Purchased by Miss Lucy Silcox from the artist through Messrs Arthur Tooth and Sons, 1935; presented at her death by her sisters to Dr Lynda Grier, who bequeathed the picture to the Tate Gallery

Exhibited: Leeds, 1947 (28); Tate Gallery, 1955 (32); Arts Council, Welsh Committee, *Stanley Spencer: Religious Paintings*, 1965 (14), repr.; London, Royal Academy, 1968 (471)

Literature: The Nineteenth Century and After, CXVII, June 1935, pp. 703–711; E. Rothenstein, 1945, repr. plates 46–47; G. Spencer, 1961, pp. 180–1; M. Collis, 1962, pp. 25, 100, 114–7, repr. in colour on dust jacket; *Royal Academy Illustrated*, 1968, repr. p. 21

One of the most controversial of Spencer's paintings, it was the rejection of this and *The Dustman* or *Lovers* by the hanging committee of the Royal Academy which led to his well-publicised resignation in 1935. Among the newspaper accounts was one, in the *Sunday Graphic and Sunday News*, 28 April 1935, which quoted Hilda Spencer on the origins of the picture. It was, she explained, based upon a drawing Spencer made in 1924 after he received a letter from her in which she mentioned that she had been reading in a haystack. 'In this picture, the main composition was originally a farm-yard scene . . . the figure of St Francis together with the roof, have been fitted into the bulk and main lines of what was originally a hay-stack with a figure reading a book. The back of St Francis takes the line down the front of the figure on the haystack, and the chord round his waist takes the lines of the shoulders and arm of the figure.' The draw-ing appears as an illustration for *August* in the Chatto and Windus *Almanack* for 1927.

Lent by the Trustees of the Tate Gallery

24 Washing up **1935**
Oil on canvas, 24 × 19 in

Provenance: Purchased from the artist through Messrs Arthur Tooth and Sons by **Sir Kenneth Clark**, 1937; with Leicester Galleries 1947; Mrs H. D. Walston

This painting may be compared with other domestic scenes of 1935–36, *Workmen in the House* and *Dusting Shelves* for instance. Like these, it belongs to the 'Cana' scheme, a series of pictures which would celebrate the importance of everyday actions and show that 'all ordinary acts such as the sewing on of a button are religious things and a part of perfection'.

Lent by Lord and Lady Walston

25 Workmen in the House **1935**
Oil on canvas, 44½ × 36½ in

Provenance: Purchased from the artist by W. A. Evill, 1937; Miss Honor Frost

Exhibited: London, Royal Academy, 1935 (701); Norwich Castle Museum, *Contemporary British and French Art*, 1938 (47); British Institute of Adult Education, Touring Exhibition, and London, City Literary Institute, *French and English Paintings*, 1939–40; CEMA, *English Life*, 1942 (60); Paris, Musée d'Art Moderne, Unesco, *Exposition Internationale d'Art Moderne*, 1946 (53); Leeds, 1947 (29); Tate, 1955 (33), repr. on cover; Brighton Art Gallery, *The Wilfred Evill Collection*, 1965 (201)

Literature: Royal Academy Illustrated, 1935, repr. p. 82; *The Studio*, 119, 1940, repr. p. 35; E. Rothenstein, 1945, repr. plate 45; Newton, 1947, repr. plate 19 (colour); M. Collis, 1962, pp. 114, 118; L. Collis, 1972, p. 68

In 1934, Spencer was recommended by Edward Beddington-Behrens to a building contractor who commissioned him to paint an appropriate subject. The following year he produced this picture with its companion piece *The Builders* (Yale University Art Gallery). Both were turned down for being 'not up to specification.' For the artist, the picture belonged to the 'Cana' section of his projected chapel in which domestic commonplace was to be invested with religious significance. He sent the picture to the Academy in 1935 where reaction was mixed. 'What many people object to,' the reviewer in the *Daily Mail* wrote, 'are some of his subjects when these are imaginative conceptions . . . *Workmen in the House* depicts a tragi-comedy. A queer-looking carpenter gazes down the length of an enormous saw, another man is half-way up the kitchen chimney, in the foreground a distracted housewife and her child sprawl on the floor.' In fact the painting represents the kitchen of Chapel View, Burghclere, with Elsie minding one of the Spencers' daughters while two workmen mend the fireplace.

Lent by Miss Honor Frost

26 Making columns for the church *c.* **1935**
Oil on canvas, 21¼ × 19¾ in

Provenance: From the collection of Mrs Gwen Raverat

The composition for this picture appears in the right-hand corner of the oil-sketch *Building a church* (no. 15). The clear modelling of the figures astride their work may be compared with *Builders* of 1935.

Lent anonymously

27 Love among the Nations **1935–36**
Oil on canvas, 37⅝ × 110¼ in

Provenance: Purchased from the artist by J. L. Behrend 1936; sold to Wilfrid Ariel Evill, *c.* 1948; by whom bequeathed to the Fitzwilliam Museum, 1963.

Exhibited: Tooth, 1936 (21); Leeds, 1947 (30); London, Tate Gallery (Contemporary Art Society), *Seventeen collectors*, 1952 (229); Tate Gallery, 1955 (34); Brighton Art Gallery, *The Wilfrid Evill Collection*, 1965 (205); Cambridge, Kettle's Yard Gallery, *Opening Exhibition*, 1970 (5)

Literature: M. Collis, London 1962, pp. 137–39, 244; *Burlington Magazine*, CVII, 1965, p. 595, repr.; L. Collis, 1972, p. 75, detail repr. facing p. 89.

This picture, which was originally entitled *Humanity*, expresses Spencer's faith in sexual love, and its powers of reconciliation. Maurice Collis (*op. cit.*, p. 138) quotes the artist: 'During the war, when I contemplated the horror of my life and the lives of those with me, I felt that the only way to end the ghastly experience would be if everyone suddenly decided to indulge in every degree and form of sexual love, carnal love, bestiality, anything you like to call it. These are the joyful inheritances of mankind.' Naturally he included himself in this depiction of terrestrial harmony. He appears seated to the right, his arms around a couple of young negresses.

Lent by the Fitzwilliam Museum, Cambridge

28 Cookham Rise: Cottages **1935**
 Oil on canvas, 29¾ × 19½ in

Provenance: Sold by Messrs Arthur Tooth and Sons
to Dr Lynda Grier, 1935

This picture of cottage gardens may be compared
with *Gardens in the Pound, Cookham* (Leeds City Art
Galleries). Of such views, Elizabeth Rothenstein
wrote, 'he could paint semi-detached houses and
suburban front gardens with an exaltation and pride
that a century earlier had gone into paintings of
Tivoli and the Campagna'.

Lent by the Trustees of the Lynda Grier Collection

29 Bellrope Meadow **1936**
 Oil on canvas, 26 × 51 in

Provenance: Sold by Messrs Arthur Tooth and Sons
to J. W. Freshfield, 1936; and to the Art Gallery,
Rochdale, 1941

Exhibited: London, National Gallery, *British Paint-
ing since Whistler,* 1940; Arts Council, Welsh
Committee, 1950; Barnsley, Cannon Hall, 1959;
Tourcoing, France, *English Week,* 1960; Plymouth
1963 (20)

Literature: E. Rothenstein, 1945, repr. plate 70

Of landscapes like this and nos. 28, 30, 31, Spencer
tended to be dismissive. He painted them at the time
when he was becoming more and more involved with
his symbolic pictures, for which he did not find a
ready market. These, on the other hand, were saleable
items of which his agent, Dudley Tooth, could never
have too many. As Maurice Collis observed, 'he
probably enjoyed doing such work more than he
admitted'.

Lent by the Rochdale Art Gallery

30 The Boat-builders Yard, Cookham **1936**
 Oil on canvas, 34⅛ × 28⅛ in

Provenance: Purchased for the City of Manchester Art
Galleries from the artist through Messrs Arthur
Tooth and Sons, 1936

Exhibited: Edinburgh, Royal Scottish Academy,
1939 (221); Arts Council, Welsh Committee, 1950
(73); Swansea, Glynn Vivian Art Gallery, *An
Exhibition of Paintings from Manchester Art Gallery
Permanent Collection,* 1952; Edinburgh, Royal
Scottish Academy, 1953 (179); Tate Gallery, 1955
(41); Barnsley, Cannon Hall, Cawthorne, *Four*

Modern Masters, 1959 (30); Arts Council of Great
Britain, touring exhibition, *Three Masters of Modern
British Painting,* 1961 (31); Plymouth, 1963 (22)

Lent by the City of Manchester Art Galleries

31 Cookham Moor **1937**
 Oil on canvas, 19½ × 29¾ in

Provenance: Purchased for the City of Manchester
Art Galleries from the artist through Messrs Arthur
Tooth and Sons, 1937

Exhibited: Mansfield Art Gallery, 1948; London,
Roland, Browse and Delbanco Gallery, *The English
Scene – Important British Paintings from Three
Centuries,* 1951 (18); Tate Gallery, 1955 (44);
Brighouse Art Gallery, *Jubilee Exhibition 1907–57:
British Painting,* 1957 (69); Adelaide, National
Gallery of South Australia, *Stanley Spencer,* 1966
(12)

Literature: Newton, 1947, repr. plate 21 (colour);
The British Heritage, London, 1948, repr. plate IV;
M. Collis, 1962, pp. 129–30, 133, 245, repr. facing
p. 33; *Cookham Festival Souvenir Programme,* 1967,
repr. cover

Another of the paintings of Cookham. The view is
along the road across the moor towards the War
Memorial. Whatever disclaimers Spencer might have
offered, works such as this invite comparison with the
landscapes of his contemporaries at the Slade, with the
Nash brothers in particular.

Lent by the City of Manchester Art Galleries

32 Cows at Cookham **1936**
 Oil on canvas, 30 × 20 in
 Signed with initials and dated '36'

Provenance: From the collection of Thomas Balston,
by whom bequeathed to the Ashmolean Museum
through the National Art-Collections Fund, 1968

Exhibited: Leeds, Temple Newsam House, 1947 (35);
Arts Council of Great Britain, *Second Anthology of
British Painting 1925–50,* 1951 (91); Cookham,
1958 (7)

Literature: E. Rothenstein, 1945, repr. plate 45;
Newton, 1947, repr. plate 26

The painting is based upon one of the drawings
Spencer made at least ten years earlier, an illustration
for the month of May for the Chatto and Windus

Almanack, published in 1927. The drawing was exhibited by the Arts Council, 1954 (20), lent by W. A. Evill, Esq.

Lent by the Ashmolean Museum, Oxford

33 Self-portrait **1936**
Oil on canvas, $24\frac{3}{16} \times 18\frac{1}{8}$ in
Signed and dated, lower right, 'S S 36'

Provenance: Bought by the Stedelijk **Museum**, Amsterdam, from Messrs Arthur **Tooth** and Sons, 1936

Exhibited: Tooth, 1936 (25); Amsterdam, Stedelijk Museum, *Twee Eeuwen Engelse Kunst,* 1936 (147)

Lent by the Stedelijk Museum, Amsterdam

34 Self-portrait with Patricia **1936–37**
Oil on canvas, 24 × 36 in

Provenance: Wilfrid Ariel Evill, by **whom** bequeathed to the Fitzwilliam Museum, 1963

Exhibited: Cambridge, Fitzwilliam **Museum,** 1949–50; Brighton Art Gallery, *The Wilfrid Evill Collection,* 1965 (206)

Literature: E. Rothenstein, 1945, p. 11 detail repr.; M. Collis, 1962, pp. 125, 245; *Burlington Magazine,* CVII, 1965, p. 595 (repr.); L. Collis, 1972, pp. 62, 106, repr. facing p. 40

During the winter 1936–37, Spencer drew and painted himself and Patricia in the most intimate and detailed of all his self-revelations. The close **range** and sharp focus were deliberate, enabling him to feel that he was crawling over the contours of the nudes like an ant. Like the *Leg of Mutton Nude* in the Tate Gallery, this picture is in contrast with the flower **paintings** and landscapes with which the 'public' artist was busy at the same time, in an attempt to solve **his** financial problems.

Lent by the Fitzwilliam Museum, Cambridge

35 Beatitudes of Love, IV. Desire **1937**
Oil on canvas, 30 × 20 in

Provenance: Purchased from the artist **through** Messrs Arthur **Tooth** and Sons, 1951

Exhibited: Leicester Galleries, 1942 (38); British Council, European tour, *Twelve Contemporary Painters,* 1948–49; Tate Gallery, 1955 (48)

Literature: The Studio, 147, 1954, p. 39; M. Collis, 1962, pp. 141, 144–5, 245; E. Rothenstein, 1962, repr. plate 10; L. Collis, 1972, pp. 107–8

For an account of Spencer's *Beatitudes* in relation to his *Church-House* scheme, see Antony Gormley's essay above. In spite of pressure to solve his financial problems by painting more popular landscapes, Spencer devoted a great deal of time to these *Couples* in which a self-reminiscent small man is both attracted to and enveloped by a much larger female companion. Although there is an undeniable humour about the result, Spencer took them very seriously and appears to have been genuinely surprised by unfavourable reactions, like that of Sir Edward Marsh: 'It fogged his monocle; he had to keep wiping it and having another go. "Oh Stanley, are people really like that?" I said. "What's the matter with them? They're all right aren't they?" "Terrible, terrible, Stanley."' (Stanley Spencer, quoted by M. Collis, p. 144)

Lent by Lord and Lady Walston

36 Beatitudes of Love, V. Contemplation **1937**
Oil on canvas, 36 × 24 in

Provenance: Bequeathed by Sir Frederick Hooper to the Stanley Spencer Gallery, Cookham, 1963

Exhibited: Worthing, 1961 (15)

Of this *Beatitude,* Spencer wrote: 'They are all engaged in a communion of love with each other. The two chief figures contemplate and look at each other with the same satisfaction and absorption as they would if they gazed at some inanimate object or animal that interested and absorbed their attention. But they find a new kind of satisfaction in being able to look in this way at each other. I like the way this bunch of people are looking about for faces to look at.

 'Their communing is helping to compose the picture and the composition is helping and aiding the communion. I feel about the composition of this and the composition of the old couple and the young couple that they fit on to or against each other as if they were two parts or two organs of one body. They seem to find their place of rest where they can best serve each other in the same way as a liver will adapt itself to the shape of a stomach and so on.'

Lent by the Stanley Spencer Gallery, Cookham

37 **Hilda, Unity and Dolls**　　　　**1937**
Oil on canvas, 30 × 20 in

Provenance: Purchased for the Leeds City Art Galleries from the artist through Messrs Arthur Tooth and Sons, 1938

Exhibited: Leeds, 1947 (49), repr.; Tate Gallery, 1955 (43), repr. plate 5; Plymouth, 1963 (24)

Literature: E. Rothenstein, 1945, repr. plate 62; *Leeds Art Calendar*, vol 8, no. 29, 1955; M. Collis, 1962, pp. 135, 245; E. Rothenstein, 1962, repr. plate 10 (colour); L. Collis, 1972, repr. facing p. 25

Painted at the Carlines' house in Pond Street, Hampstead, when Spencer stayed there for two weeks or so, towards the end of August, 1937. His second daughter, Unity, was seven years old at the time.

Lent by the Leeds City Art Galleries

38 **Landscape in North Wales**　　　　**1938**
Oil on canvas, 22 × 27⅞ in

Provenance: Arthur Tooth and Sons; Edward Maurice Berkeley Ingram CMG OBE, by whom bequeathed to the Fitzwilliam Museum, 1941

Exhibited: London, National Gallery, *British Painting Since Whistler*, 1940 (131); Redfern Gallery, *Collection of Paintings formed by the late Maurice Ingram*, 1941 (40)

On 29th August 1938, Spencer informed Dudley Tooth by letter that he would be away. He planned a visit to North Wales where, by 7th September, he was staying with Mrs Carline and Hilda in a house which belonged to a friend of theirs, Mrs Johnson, near Snowdon. By 14th October he was back in Cookham, having painted at least two landscapes in Wales; a view of *Snowdon from Llanfrothen* is in the National Museum of Wales.

Lent by the Fitzwilliam Museum, Cambridge

39 **Self-portrait**　　　　**1939**
Oil on canvas, 15⅝ × 21¾ in

Provenance: Purchased by the Friends of the Fitzwilliam Museum, 1942

Exhibited: Leicester Galleries, 1942 (16); Cookham, 1965; Cambridge, Kettle's Yard Gallery, *Opening Exhibition*, 1970 (7)

The artist is shown holding the brush in his left-hand. Spencer was not left-handed; an apparent contra-

diction attributed by his brother Gilbert to the use of a single mirror.

Lent by the Fitzwilliam Museum, Cambridge

40 **The Wool Shop**　　　　**1940**
Oil on canvas, 36 × 24 in

Exhibited: Leeds, 1947 (64); Worthing, 1961 (19); Plymouth, 1963 (34)

Literature: Newton, 1947 plate 27 (colour); M. Collis, 1962, pp. 163, 246

The painting is based upon one of the 'Scrapbook' drawings which belonged to Lord Astor. It describes a visit to a shop in Stonehouse, Gloucestershire, by Spencer and Daphne Charlton at the time of his stay with the Charltons at the White Hart Inn at Leonard Stanley.

Lent anonymously

41 **Shipbuilders on the Clyde: Burners**　　**1940**
Oil on canvas. Triptych, centre panel 42 × 60 in, *side panels each* 20 × 80 in

Provenance: Officially commissioned by the War Artists' Advisory Committee, 1940; presented to the Imperial War Museum, 1947

Exhibited: London, National Gallery, after completion, and on tour during the war; Glasgow Art Gallery, *War Artists' Exhibition*, 1945; Cookham (n.d.); Glasgow, 1975 (1)

Literature: Newton 1947, centre panel repr. plate 31 (colour); E. Rothenstein, 1945, repr. plates 81–2; *idem.* 1962, repr.

For a detailed account of Spencer's activity as an Official War Artist, 1940–46, see Robin Johnson, above. *Burners* was the first part of the polyptych to be completed. Spencer was paid £150 for it in the autumn of 1940.

Lent by the Imperial War Museum

42 **Seated nude**　　　　**1942**
Oil on canvas, 30 × 20 in

Provenance: Leicester Galleries 1942; sold to Leger Gallery; sold to Mrs H. D. Walston, 1943

Exhibited: Leicester Galleries 1942 (15); Tate Gallery, 1955 (64)

The painting was done from a much earlier drawing of Spencer's first wife, Hilda. A cool, almost academic

study, it betrays neither the tensions in their relationship nor the obsessive intimacy of his pictures of nudes of *c.* 1937.

Lent by Lord and Lady Walston

43 The Resurrection: Reunion 1945
Oil on canvas. Triptych, centre and sides each 30 × 20 in

Provenance: Purchased from Messrs Arthur Tooth and Sons, 1952

Exhibited: London, Royal Academy, *Summer Exhibition*, 1950 (567); British Council, touring exhibition to Canada and USA, *21 Modern British Painters*, 1951 (32); Tate Gallery, 1955 (71); Arts Council, Welsh Committee, *Stanley Spencer: Religious Paintings*, 1965; Cookham Festival, 1975

Literature: R. H. Wilenski 1951, pp. 4, 12, 22, 24, repr. in colour, plates 5 and 10; Aberdeen Art Gallery, Annual Report, 1952; *The Studio*, 147, 1954, p. 34, repr.; L. Collis, 1972, detail repr. facing p. 121

The theme of Resurrection was a recurrent one throughout Spencer's life. In 1914, at the age of twenty-three, he painted the small diptych, the *Resurrection of the Good and Bad* (private collection). In 1926 he completed the *Resurrection: Cookham* (Tate Gallery) and for the following five years, he was occupied with the Burghclere Chapel, which involved a more ambitious realisation of the same subject. At Leonard Stanley in 1940, Spencer was attracted once more by the idea of painting a Resurrection, but it was his war-time visits to Port Glasgow which turned the plan into action. He explained; 'One evening in Port Glasgow, when unable to write due to a jazz band playing in the drawing-room just below me, I walked up along the road past the gas works to where I saw a cemetery on a gently rising slope . . . I seemed then to see that it rose in the midst of a great plain and that all in the plain were resurrecting and moving towards it. . . . I knew then that the Resurrection would be directed from this hill.' In Port Glasgow, the people and place combined to inspire Spencer as Cookham and Macedonia had done earlier. As time went on, he became less enthusiastic about his commission as an Official War Artist, and more engrossed in his scheme for a series of Port Glasgow Resurrections. When he returned to Cookham at the end of the War, he had completed seven canvases, to which eleven more were added by 1950 to comprise five triptychs and three single canvases. The scale of the finished work is comparable to the Burghclere Chapel, but without a similar patron to realise his dreams, Spencer had to witness the dispersal of his Port Glasgow Resurrections.

'In *Reunion*,' he explained, 'I have tried to suggest the circumstances of the Resurrection through a harmony between the quick and the dead, between the visitors to a cemetery and the dead now rising from it. These visitors are in the central panel, and the resurrected are in the panels right and left.' In the left-hand section, among the neat rows of sepulchral wrought-iron, Spencer included himself and his two wives. Of that part of the triptych, he explained, 'Here I had the feeling that each grave forms a part of a person's home just as their front gardens do, so that a row of graves and a row of cottage gardens have much the same meaning for me. Also although the people are adult or any age, I think of them in cribs or prams or mangers. "Grown ups in prams" would express what I was after. . . .'

Lent by the Aberdeen Art Gallery

44 The Resurrection with the Raising of Jairus' Daughter 1947
Oil on canvas. Triptych, centre panel 30¼ × 34¾ in, *side panels each* 30¾ × 20¼ in

Provenance: Purchased by Southampton Art Gallery (Smith Bequest Fund), from the artist through Messrs Arthur Tooth and Sons, 1950

Exhibited: Tooth, 1950 (15); Bournemouth Arts Club, *Contemporary British Painting*, 1952 (54); London, Arts Council Gallery, *Paintings from Southern and Midland Galleries*, 1953 (31) repr. plate III (centre panel); Exeter Art Gallery, *Contemporary Paintings from Southampton Art Gallery*, 1955 (24); Tate Gallery, 1955 (72)

Literature: R. H. Wilenski, 1951, p. 20, repr. plate 9; *Britain Today*, July 1950, pp. 36–37; M. Collis, 1962, p. 197; E. Rothenstein, 1962, repr. plate 12 (detail, colour) and black and white

In 1951, Spencer explained 'this painting does not in one sense belong to this resurrection group because the two side-panels were drawn when I was at Stonehouse in Gloucestershire in 1940; but the composing and drawing of the window scene in the centre panel (which links the side-panels) was done in Port Glasgow.' In common with Spencer's benign view of the Resurrection, the dead rising in the left-hand panel are treated as homecomers. 'In order to further make clear my feeling of happiness,' he explained, 'I put over the doors the usual "Welcome Home" signs and flags and bunting they put up for the soldiers returning from the war.'

Lent by the Southampton Art Gallery

45 Cookham from Englefield **1948**
 Oil on canvas, 30 × 20 in

Provenance: Commissioned from the artist by Mr George Gerard Shiel

Exhibited: Tooth, 1950 (6); Exhibition in Cookham Church and Vicarage, 1958; Worthing, 1961 (30); Cookham, 1971, 1974, 1975–76; Cookham, Odney Club, *The Gerard Shiel Collection of Stanley Spencer Paintings*, 1975 (1)

Gerard Shiel took a lease of Englefield, Cookham, in 1940, and settled there permanently after the war. After meeting Spencer, he formed a collection of his work and commissioned paintings, five in all, of his house and its grounds. This was the first of them. It is dated 1948 in the artist's chronological list of his works (p. 304), where it is described as *Cedar and Cookham from Englefield*. Mr Shiel, who died in 1975, was a Founder Member, Trustee, and sometime Chairman of the Trustees, of the Stanley Spencer Gallery, Cookham.

Lent by the Executors of the late G. G. Shiel

46 Angels of the Apocalypse **1949**
 Oil on canvas, 24 × 35 in

Provenance: Purchased by G. Corcoran from the artist through Messrs Arthur Tooth and Sons, 1950; sold to Tully Grigg 1950; Mrs Arthur Gibbs; Lord Hayter

Exhibited: Tooth, *Today and Yesterday*, 1949 (6); Tooth 1950 (2) repr.; Tate Gallery 1955 (75); Cookham Church, *Stanley Spencer Exhibition*, 1958 (o)

Literature: Herbert Read, *Contemporary British Art*, Harmondsworth, 1947 repr. plate 42

The picture stems from Spencer's wish to paint skies filled with angels to go above his *Resurrection: The Hill of Sion* of 1946 (Harris Museum and Art Gallery, Preston). Instead of making them agents of divine retribution in accordance with the prophecy in the Book of Revelation (Chapter 16), Spencer harmonised the angels with his almost cosy notion of Last Judgment. In place of the vials of wrath they pour seed and fertiliser on to the earth. He regarded them, finally, as Angels of the Creation rather than of the Apocalypse.

Lent by The Lord Hayter CBE

47 Love Letters **1950**
 Oil on canvas, 34 × 46 in

Provenance: Messrs Arthur Tooth and Sons; Professor N. B. B. Symons

Exhibited: Tooth, 1950 (10); Pittsburgh, Carnegie Institute, *International Exhibition of Paintings*, 1950 (187), repr. plate 41; Tate Gallery 1955 (77); Tooth, 1960 (repr.); Cookham, 1967

Literature: M. Collis 1962, pp. 214, 247, repr. facing p. 192

Painted in the year of Hilda's death, the picture commemorates Spencer's interminable correspondence with his first wife which began at Burghclere and which was to continue, one-sided, until his own death nine years after hers. There is an element of reminiscence in the painting. Spencer had formed the habit while they were married of reading some of his unposted letters out loud to her, but there is an unmistakable ingredient of fantasy in the cosy domestic scene in which they exchange tokens of their affection.

Lent by Professor and Mrs N. B. B. Symons

48 The Farm Gate **1950**
 Oil on canvas, 35 × 22½ in

Provenance: Presented to the Royal Academy by the artist as his Diploma Painting, 1950

Exhibited: London, Royal Academy, *Summer Exhibition*, 1951 (479); *A Selection of Diploma Works*, 1954; Tate Gallery, 1955 (76), repr. plate 8; Worthing, 1961 (32); Plymouth, 1963 (39); Bournemouth, 1965 (59); Royal Academy, *Winter Exhibition*, 1968 (470)

Literature: E. Rothenstein, 1962, repr. plate 13

The farmyard is the familiar one across the road from Fernlea; the view down into it that from one of the bedroom windows in the Spencers' family house. As Elizabeth Rothenstein points out (*op. cit.*), the picture was 'painted some forty years later from the memories of home that lay stored in his mind'. A detailed, preparatory drawing for the painting, squared for transfer, is exhibited here (no. 84).

Lent by the Royal Academy of Arts, London

49 The Marriage at Cana: Bride and Bridegroom **1953**
Oil on canvas, 26 × 20 in

Provenance: Purchased for the Glynn Vivian Art Gallery from the artist through Messrs Arthur Tooth and Sons, 1958

Exhibited: Arts Council, 1961 (38); Plymouth, 1963 (43)

Literature: L. Collis 1972, p. 135, repr. facing p. 20

The subject of the picture goes back to Spencer's plans, conceived in the 'thirties, for a Church-House. As Antony Gormley explains above, *The Marriage at Cana* was to be one of its themes. Elsewhere he has written, 'the guests take part in a cycle of life through marriage. Their journey from their homes to the feast itself represents life from the age of majority to marriage. The return journey symbolises the passing-on of life possible through marriage – the children that result from the union of man and wife. Thus Cana becomes a symbol of life through marriage . . .' Spencer returned to the subject in 1953 when he painted, in addition to this canvas, one entitled simply *Marriage at Cana* (36 × 60 in, private collection) and made a sepia drawing of the *Servant announcing the miracle* (21¾ × 29½ in, private collection). In this composition, the principal figures are those of Hilda and Stanley Spencer. The painting refers back to their marriage and forward to the second marriage to Hilda which Spencer had contemplated during her lifetime and to which he became even more committed after her death.

Lent by the Glynn Vivian Gallery and Museum, Swansea

50 Love on the Moor **1949-54**
Oil on canvas, 31⅛ × 122⅛ in

Provenance: William Ariel Evill, by whom bequeathed to the Fitzwilliam Museum, 1963

Exhibited: Brighton Art Gallery, *The Wilfrid Evill Collection*, 1965 (204)

Literature: M. Collis, 1962, pp. 213–14, 220, 247, repr. p. 176 (centre detail); *Burlington Magazine*,

CVII, 1965, p. 595 (repr.); L. Collis, 1972, pp. 107, 158–59, repr. p. 137 (detail to right)

The painting celebrates the apotheosis of Hilda, depicted as a statue of Venus on Cookham Moor. It is almost the last word on a number of Spencer's life-long predilections; the setting is that familiar spot, the centre of his personal universe. Hilda is shown as a goddess, eternally young, carefree and voluptuous, in the role she assumed for the artist, especially after her death. Her juxtaposition with a recumbent, spotted cow, its back legs those of a woman in a spotted dress, is neither incidental nor irreverent. Equally pointed is the basket of letters which refers to the lengthy, largely one-sided correspondence. The abased figure entwined around the legs of the principal statue can only refer to Spencer himself. Together and marmoreal, he and Hilda preside over groups of figures who are reminiscent of the *Resurrections* crowds, greeting one another and love-making in honour of the deity. The celebrants also give and receive presents, try on clothes and smell flowers, all familiar pastimes with a special significance for the artist. Together with his *Cookham Regatta* project, the subject of the *Apotheosis of Hilda* dominated the last ten years of Spencer's life; his last great images of both, more than 120 square feet apiece, were unfinished when he died in 1959.

Lent by the Fitzwilliam Museum, Cambridge

51 The Dustbin, Cookham **1956**
Oil on canvas, 30 × 20 in

Provenance: Purchased by the Royal Academy of Arts (Harrison Weir Fund), 1956

Exhibited: London, Royal Academy, 1956 (56); Arts Council, 1961 (40); Cookham, 1962 (21), and subsequently

Literature: Royal Academy Illustrated, 1956, p. 14, repr.

The painting is based upon one of the drawings Spencer made for the month of September for the Chatto and Windus *Almanack*, 1927.

Lent by the Royal Academy of Arts, London

Drawings

52 The Fairy on the Waterlily Leaf 1910
Pen and ink, $16\frac{1}{2} \times 12\frac{1}{2}$ in

Provenance: Given by the artist to Ruth, Lady Gollancz (née Lowy) as a wedding present, 22 July 1919; bequeathed by her to the Stanley Spencer Gallery, Cookham, 1973

Exhibited: London, National Gallery, *Twentieth Century British Paintings,* 1940; Leeds, 1947 (85); Worthing, 1961 (1); Plymouth, 1963 (58)

Literature: E. Rothenstein, 1945, repr. plate 1

Spencer knew Ruth Lowy from boyhood. Her family owned a house near the river, and the Spencer brothers used to join them for boating trips. She was also a student at the Slade. In fact the subject of the drawing may have been one set by the Slade Sketch Club. When Lady Gollancz asked Spencer to identify the story he wrote; 'I do not know that my picture is called anything. The lady on the waterlily leaf is a Fairy if you please, and of course the boy on the bank is Edmunds, but honestly I do not know what the picture is all about. You might give the persons depicted a different name for every day in the week with special names for High days and Holidays'. (Quoted by Victor Gollancz, *Reminiscences of Affection,* London, 1968, p. 110). Edmunds was a model who posed at the Slade. For the legs and arms of the principal figure, Lady Gollancz suggested that Spencer perhaps used his own. The style of the drawing, with its hard, incisive lines and angular poses indicates Spencer's interest in the kind of early northern draughtsmanship, German in particular, which had appealed to the Pre-Raphaelites a generation or so earlier.

Lent by the Stanley Spencer Gallery, Cookham

53 Study for 'Apple Gatherers' *c.* 1912
Pen, pencil and wash, squared for transfer, $10\frac{7}{8} \times 12\frac{5}{8}$ in

Provenance: Sir Edward Marsh, who probably obtained it direct from the artist; bequeathed by him to the Tate Gallery through the Contemporary Art Society, 1954

Exhibited: British Council, *Empire Exhibition,* Johannesburg, 1936 (703); Leeds, 1947 (80); London, Leicester Galleries, *The Collection of the late Sir Edward Marsh,* 1953 (4)

A sketch which Spencer made while at the Slade School, for his painting of 1912–13 (Tate Gallery). It was a Slade Sketch Club subject which the artist pondered for a long time. The drawing shows the final composition he executed, but less compact and tightly organised than in the finished picture.

Lent by the Trustees of the Tate Gallery

54 Self-portrait 1913
Pen and ink, $8\frac{1}{2} \times 14$ in
Inscribed lower left, 'Dec 1913'; *lower right,* 'To John Rothenstein/from Stanley Spencer'

Provenance: as above

Exhibited: Arts Council, 1954 (11)

Literature: E. Rothenstein, 1945, plate 55; *idem.,* 1962, plate 55

Lent by Sir John and Lady Rothenstein

55 Study for 'Christ Carrying the Cross' 1919-20
Pencil and sepia wash, squared for transfer, $14\frac{1}{4} \times 13\frac{3}{8}$ in

Provenance: Given to Richard Carline by the artist after his first exhibition at the Goupil Gallery, 1927

Exhibited: Goupil Gallery, 1927 (15); Arts Council, 1954 (15); Plymouth, 1963 (62)

A study for the oil of 1920 in the Tate Gallery, painted by Spencer while he was staying with the Slessers' at Bourne End. The artist explained that the idea for the picture came from a newspaper report of Queen Victoria's funeral, at which 'ladies were weeping openly and strong men broke down in the side streets'. The house in the composition is Fernlea, the Spencers' family home.

Lent by Richard Carline, Esq

56 and 57 Studies for Burghclere Chapel 1923
Pencil and wash on paper, each $22 \times 28\frac{1}{2}$ in

Provenance: J. L. Behrend, who presented them to the Stanley Spencer Gallery, Cookham, through the Friends of the Gallery, 1972

Exhibited: Goupil Gallery, 1927 (3) and (7); Leicester Galleries, 1942 (49) and (50)

The drawings are studies for the north and south walls of the Burghclere Chapel (see pp. 18-20). Presumably they were made soon after the Behrends had expressed enthusiasm for the project and before instructions were given to the architect of the building. The drawing for the north wall shows that at one time, Spencer planned for the third bay a painting of an operating theatre. He wrote to his friend Desmond Chute in the summer of 1916 about an operation he witnessed as an orderly at the Beaufort Medical Hospital in Bristol, 'it is wonderful how mysterious the hands look, wonderfully intense'. He illustrated the point with a drawing in the letter of surgical instruments radiating from an incision in the patient's abdomen. In the final scheme, however, the subject is replaced by *Kit Inspection*, here indicated as the final scene, nearest the altar, on the north wall. That bay was, in turn, executed with *The Dugout*, which does not appear in this cartoon.

Lent by the Stanley Spencer Gallery, Cookham

58 **Camouflaged Grenadier** 1923
Pencil and wash, squared for transfer, $19\frac{7}{8} \times 14\frac{5}{8}$ in
Inscribed lower centre, 'Camouflaged Grenadier. 9'

Verso: Two compositional studies for Burghclere Chapel

Provenance: Purchased from the Goupil Gallery by the Tate Gallery (Duveen Drawings Fund), 1927

Exhibited: Goupil Gallery, 1927 (5)

The drawing is a study for the soldier in the foreground of the fourth central bay, nearest the altar, on the north wall of the Burghclere Chapel. It is a portrait from memory of a soldier Spencer knew, a particularly daring man who was killed in action in Macedonia. (Information from Gilbert Spencer, quoted in the Tate Gallery catalogue, 1964, p. 662.)

Lent by the Trustees of the Tate Gallery

59 **Portrait of Gilbert Spencer** 1925
Pencil on paper, 14×10 in
Inscribed by Hilda Spencer in pencil, lower right 'Gilbert by Stan, on our honeymoon'

Provenance: from the artist's studio

Drawn at Wangford in 1925. See note for no. 14

Lent by Richard Carline, Esq

60 **Self-portrait** *c.* **1926**
Pencil, $12 \times 7\frac{1}{8}$ in
Signed in pencil, lower right, 'Stanley Spencer – 1926?'

Provenance: Bought by the Arts Council of Great Britain from Messrs Arthur Tooth and Sons, 1954

Exhibited: Arts Council, 1954 (25), repr. on cover; Arts Council, *Decade 1920–30*, touring exhibition 1970 (137)

Lent by the Arts Council of Great Britain

61 **The month of January: Afternoon tea** 1926
Pen and ink, $16\frac{3}{4} \times 9\frac{1}{2}$ in, *ruled margins*
Signed in pencil, lower right, 'Stanley Spencer'
Inscribed by the artist, in pencil, centre 'January', *and in another hand* 'Reduce to 4″ . . .'

Provenance: Given by the artist to Richard Carline

Exhibited: Goupil Gallery, 1927 (34); London, Leicester Galleries, *Artists as Collectors*, 1963; Cookham Festival, Odney Club, *The Spencers and the Carlines in Hampstead in the 1920s*, 1973 (9); London, Harvane Gallery, *Hampstead I*, 1973 (4)

This and the following two drawings belong to a series of twenty-four illustrations to an Almanack published by Chatto and Windus in 1927. A copy of the book is included in the exhibition.

January is a drawing of the Carlines' studio, 14a Downshire Hill. It shows Richard Carline, back view, facing Kate Foster over the tea-tray brought back from Bosnia in 1922.

Lent by Richard Carline, Esq

62 **The month of June: Gathering flowers** 1926
Pen and ink, $21\frac{1}{2} \times 15$ in
Inscribed by the artist in pencil, centre, 'June', *and in another hand, lower right,* 'Reduce to $4\frac{3}{4}$ in in height'

Provenance: Given by the artist to Richard Carline

Exhibited: Plymouth, 1963 (64)

Drawn for the Chatto and Windus *Almanack*. A coloured reproduction of this drawing has been made by the Stanley Spencer Gallery, Cookham.

Lent by Richard Carline, Esq

63 The month of December: Christmas Stockings **1926**
Pen and ink, $10\frac{1}{8} \times 16\frac{5}{8}$ in

Provenance: Given by the artist to Richard Carline

Exhibited: Goupil Gallery, 1927 (32); Plymouth, 1963 (66); China, *British Graphic Art and Book Illustration,* 1956

Drawn at the Vale Hotel, Hampstead, for the Chatto and Windus *Almanack.* The composition was used by Spencer in 1936 for the painting with the same title which is in the Museum of Modern Art, New York.

Lent by Richard Carline, Esq

64 Portrait of Hilda Spencer **1928**
Pencil, 14×10 in
Signed and dated, lower right, 'Stanley Spencer 1928'

Provenance: Mrs F. L. Evans; presented to the Ashmolean Museum in accordance with her wishes by Mrs Taylour and Mr Powys Evans, 1969

Exhibited: New York, Brooklyn Museum, *Water-colour Paintings, Pastels and Drawings by American and European Artists,* 1933 (112)

Lent by the Ashmolean Museum, Oxford

65 Portrait of Mrs Carline **1931**
Pencil, on two sheets, joined, $13\frac{3}{4} \times 12\frac{1}{2}$ in
Signed in pencil lower right, 'Stanley Spencer/ May 1931'

Provenance: Given by the artist to Richard Carline, on the death of Mrs Carline, 1945

Exhibited: Plymouth, 1963 (71)

A drawing of Spencer's mother-in-law, Mrs Anne Carline, the wife of one painter and the mother of three others. She herself began to paint in 1927. This drawing was done, according to Richard Carline, at the Spencers' home at Burghclere.

Lent by Richard Carline, Esq

66 Hilda with hair down **1931**
Pencil, two sheets, joined, $24\frac{1}{8} \times 17\frac{3}{4}$ in
Signed in pencil, lower right, 'Stanley Spencer/ 1931'

Provenance: In the artist's collection at the time of his death; purchased by Richard Carline through Messrs Arthur Tooth and Sons

Exhibited: Arts Council, 1954 (28), repr. plate III; Plymouth, 1963 (72)

Drawn at Burghclere, this is one of Spencer's most gently perceptive studies of his first wife.

Lent by Richard Carline, Esq

67 Hilda, Stanley and children walking
Pencil on paper, squared for transfer, 14×10 in
Inscribed in pencil by Richard Carline, lower right, 'Hilda, Stanley and children walking/by Stanley Spencer'

Verso: pencil sketch of a group of figures, walking, and a sketch in ink of a horse and figures seen behind foliage. Inscribed in pencil 'beginning of (?) Odney'

Provenance: from the artist's studio

Lent by Richard Carline, Esq

68 Study for 'Tiger Rug' **1939**
Pencil on buff paper, $15\frac{7}{8} \times 10\frac{3}{4}$ in
Signed and dated, lower right, 'Stanley Spencer 1939', and inscribed verso '3241/Study for Tiger Rug'

Provenance: Mrs Ursula Tyrwhitt; by whom bequeathed to the Ashmolean Museum, 1966

Exhibited: Leicester Galleries, 1942 (54)

Literature: M. Collis, 1962, pp. 162, 246

In 1940, Spencer painted *Tiger Rug* (canvas, 36×24 in, private collection) for which this drawing is a study. Collis quotes from the artist's note on the painting: 'How wonderful would *Tiger Rug* be as Resurrection picture. The rug would symbolise the man's and the woman's discarded shrouds. The paws would become sleeves and pyjama trousers, the tiger's head a stone carving of the woman's face. Their rapt staring at each other would be the rapt staring of two people awakened in paradise. How near is the meaning of resurrection and of sexual union.' In the drawing, one feels, the intimate domestic origins of the scene are more prominent.

Lent by the Ashmolean Museum, Oxford

The Scrapbook Drawings

The following sixteen drawings, in pencil on irregular sheets, approximately 16 × 11 in, are selected from a group of some hundred and fifty studies with which Spencer filled four scrapbooks between 1939 and 1949. They were acquired from his estate by the late Viscount Astor.

During his lifetime, Spencer attached great importance to what Colin Hayes has called his 'visual diary', which he regarded as a mine of compositions from which paintings could be drawn. The sheets are squared in anticipation of their transfer to canvas. A number of them have lengthy inscriptions in the artist's hand, usually on the back.

Selections of the drawings have been exhibited at Cookham, since 1962; Plymouth, 1963; London, Thomas Gibson Fine Art Ltd, 1976.

Literature: M. Collis, 1962, pp. 162, 177–8; Colin Hayes, *Scrapbook Drawings of Stanley Spencer*, Lion and Unicorn Press, London, 1964; Carolyn Leder, *Stanley Spencer. The Astor Collection*, Thomas Gibson Publishing Ltd, London 1976 (the Thomas Gibson numbers below refer to this volume in which the drawings are published *in toto* for the first time)

69 Gladiator at the Technical School, Maidenhead

Volume I, p. 22; Thomas Gibson no. 2

Verso: inscribed by the artist in pencil, 'A memory of my days at the Technicle School. Two students are talking to each other by their drawing boards. The local governers (mayor & councillors) are on an official visit. The figure is the Gladiator. Casts are on the shelves & hanging on the wall. And like the comic post card I saw of two tramps saying to each other about a cow in a field. Just think everywhere it looks it sees something to eat, so here every where one looked there was something to draw or being drawn. On the left is the back of the head of an old lady doing a water colour of rock gooseberry which was always being done. I saw some recently'.

70 Out walking

Volume I, n.p.; Thomas Gibson no. 19
Reproduced: C. Hayes, 1964, plate 2

The drawing shows Stanley and Hilda Spencer with one of their daughters, out walking a dog. Presumably drawn from memory.

71 Fetching shoes

Volume I, p. 27; Thomas Gibson no. 24
Reproduced: C. Hayes, 1964, plate 12

A number of the Scrapbook drawings are concerned with domestic commonplace, which Spencer aimed to endow with something of the sanctity of ritual. Such activity was, for him, 'a part of the religious expression of desire. All things such as these incidents, the many ordinary happenings between two lovers is all a part of the love experience. They make love through everything between themselves'.

72 Daphne drawing children

Volume I, p. 34; Thomas Gibson no. 26
Reproduced: C. Hayes, 1964, plate 15

The artist's inscription explains, 'the last day is in my treatment of it, a recording of all that to me is loving . . . this "angel" is recording them in the form of drawing them. The children being drawn are seen above the sketchbook. The ones below are a group of children blowing out bags as they like to do . . . The scene here takes place by the stable wall facing the farm pond'.

The drawing shows Daphne Charlton, with whom Spencer was at Leonard Stanley in 1940, sketching among a group of children.

73 Couple drawing each other, Stan and Mary

Volume I, p. 31; Thomas Gibson no. 27
Signed lower right
Reproduced: C. Hayes, 1964, plate 9

74 Hanging clothes on pictures

Volume II, p. 1; Thomas Gibson no. 33

This drawing illustrates an event in Spencer's life with the Charltons at the White Hart Inn, Leonard Stanley. He explained 'the everyday life I depict is in the form of ordinary acts, me putting a shirt on and Daphne Charlton hanging dresses over the pictures, as there was no wardrobe'.

75 Elsie, Miss Herren, Unity, Hilda and Stanley

Volume II, p. 8; Thomas Gibson no. 53b

In January 1943, Spencer began the drawings in his second scrapbook. A number of them are memories of his family life at Burghclere, more than ten years earlier. They often appear with long and rambling commentaries, verbal recollections of the same and intervening years. On this sheet, the soliloquy is

interrupted by 'I must do some drawing here before the space is all mopped up with writing'. Miss Herren was the Swiss nurse.

76 Taking in washing, Elsie

Volume II, p. 5; Thomas Gibson no. 61a
Reproduced: C. Hayes, 1964, plate 18

Another of Spencer's reminiscences of life at Chapel View, Burghclere. While the artist kneels with his sketchpad, Elsie collects stockings off the line and a Holy Ghost figure holds a basket of pegs. Elsie was the maid, a local girl who moved with the family to Lindworth, the house Spencer bought at Cookham in 1931. She continued to look after him there after the breakdown of his two marriages in 1937, until she left his service to get married in 1938. She occurs in a number of his compositions, always about some practical task such as chopping sticks, polishing, ironing or taking in the washing. Her instinct for domestic chores and her patience as a listener to his woes guaranteed Elsie a very special place in Spencer's affections. See also no. 85.

77 Me and Hilda, Downshire Hill

Volume II, p. 40; Thomas Gibson no. 74
Signed and dated, lower right
Reproduced: M. Collis, 1962, facing p. 60; C. Hayes, 1964, plate 27

Hilda is the formidably dominant figure in a drawing which is reminiscent of the theme of the *Beatitudes of Love* (nos. 35, 36). Spencer has also taken considerable care over the detail here, especially with the pattern and weave of the stuffs of their clothes.

78 Combing hair

Volume III, p. 2; Thomas Gibson no. 92
Signed lower right and dated March 1944
Reproduced: C. Hayes, 1964, plate 40; L. Collis, 1972, facing p. 57

The drawing shows Spencer with his second wife, Patricia. A number of the drawings commemorate their affair at Lindworth before their marriage in 1937.

79 Patricia dancing to the gramophone

Volume II, p. 12; Thomas Gibson no. 94
Reproduced: L. Collis, 1972, facing p. 56

Another of the drawings which look back to Spencer's courtship of Patricia Preece. The patriarchal figure to the right is the divine presence, a Holy Ghost, whose presence indicates approval of the couple.

80 Patricia shopping

Volume II, no. 13; Thomas Gibson no. 98

Buying presents was one of Spencer's great delights in the period of extravagance which marked his pursuit of Patricia Preece. The drawing shows them in Maidenhead, accompanied and approved by the Holy Ghost.

81 Aunt Jenny's Garden

Volume II, p. 49; Thomas Gibson no. 98
Reproduced: C. Hayes, 1964, plate 34

82 Pinning a shirt to dry on a tent

Volume IV, p. 11; Thomas Gibson no. 116a
Dated, lower right, 1946
Reproduced: C. Hayes, 1964, plate 60

The drawing is a recollection of Spencer's service in Macedonia during the First World War. In the Burghclere Chapel decorations, the *Firebelt* scene is set among the tents of an encampment.

Verso: a drawing of *Hilda finds Grandpa's grave*, dated March 1949, in other words, drawn some time later than the *recto*.

83 Christ preaching from a boat

Volume IV, p. 24; Thomas Gibson no. 134
Dated Autumn 1947

One of the early drawings for the Regatta series. See no. 94.

84 The Farm Gate

Volume IV, p. 7; Thomas Gibson no. 136a
Dated June 16th '46

The drawing from which Spencer's Diploma painting of *The Farm Gate* (no. 48) was done in 1950.

Verso: a drawing of Stanley and Hilda looking at paintings, dated February 1949

85 Elsie at Burghclere

Pencil on paper, squared, $15\frac{7}{8} \times 10\frac{3}{8}$ in

Provenance: Purchased from Thomas Gibson Fine Art Ltd, by the Friends of the Fitzwilliam Museum, 1976

Reproduced: C. Hayes, 1964, plate 49

Another of the Scrapbook Drawings, in this one Elsie, in full domestic regalia, is shown standing at the door of Chapel View, talking to a caller.

Lent by the Fitzwilliam Museum, Cambridge

86 **Study for 'Bending the Keelplate'** **1940**
Pencil, 10 × 14 in

Inscribed: 'Men cutting sheet'

Provenance: Purchased from the artist's executors by the National Art-Collections Fund, and presented to the Imperial War Museum, 1960

Exhibited: Glasgow 1975 (16)

The oil of *Bending the Keelplate* (30 × 228 in) was completed in July 1943. This preparatory study, like those which follow, was made some years earlier, probably during one of Spencer's first visits to Port Glasgow. Until he set up his studio there in the summer of 1944, he painted his canvases first at Leonard Stanley, then in Mrs Harter's house at Epsom, and finally in the studio at Lindworth in Cookham.

Lent by the Imperial War Museum

87 **Study of a man with a drill** **1940**
Pencil, $14\frac{3}{4} \times 10\frac{3}{4}$ in

Provenance: Purchased from the artist's executors by the National Art-Collections Fund, and presented to the Imperial War Museum, 1960

Lent by the Imperial War Museum

88 **Study of Spencer sketching, with Welder**
 1940
Pencil, 15 × 11 in

Provenance: Purchased from the artist's executors by the National Art-Collections Fund, and presented to the Imperial War Museum, 1960

Exhibited: Glasgow, 1975 (11)

Lent by the Imperial War Museum

89 **Study for 'Plumbers'** **1941**
Pencil, 10 × 14 in
Inscribed 'Plumbers cent'

Provenance: Purchased from the artist's executors by the National Art-Collections Fund, and presented to the Imperial War Museum, 1960

Exhibited: Glasgow, 1975 (20)

Spencer completed his painting of *Plumbers* in March 1945, although drawings like this one, upon which it was based, were done during his earlier visits to Lithgow's shipyard.

Lent by the Imperial War Museum

90 **Portrait of Shirin Spencer** **1947**
Pencil on paper, $19\frac{1}{4} \times 15$ in
Inscribed in pencil, lower right, 'Stanley Spencer'

Provenance: Messrs Arthur Tooth and Sons, from whom purchased by the Southampton Art Gallery (Smith Bequest Fund), 1960

Exhibited: Worthing, 1961 (29); London, Royal Academy, *Bicentenary Exhibition* 1968–69 (645)

Shirin, aged 21, was living with her mother and Richard Carline in Pond Street, Hampstead, when this drawing was made during one of Spencer's visits there.

Lent by the Southampton Art Gallery

91 **Portrait of Sir John Rothenstein** **1950**
Pencil, $16\frac{1}{2} \times 12\frac{5}{8}$ in
Inscribed in pencil, lower right, 'To John Rothenstein/from Stanley Spencer – Feb 1st/ 1950'

Provenance: as above

Exhibited: Arts Council, 1954 (51); Cheltenham, *Portraits of Living Writers*, 1962; Plymouth, 1963 (81)

Lent by Sir John and Lady Rothenstein

92 **The Wedding Cake** **1953**
Lithograph, $21\frac{7}{8} \times 17\frac{1}{4}$ in
Artist's proof, signed in pencil, lower right, 'Stanley Spencer'

Provenance: Given by the artist to Richard Carline, 1956

Exhibited: China, *British Graphic Art and Book Illustration*, 1956

According to Richard Carline, Spencer made only two lithographs, both of them in the early 1950's (see also no. 93). It is doubtful whether more than a few proofs were ever printed. The subject and composition of this one recur in the painting *Bride and Bridegroom* of 1953

Lent by Richard Carline, Esq

93 **Retrieving a ball** **1954**
Lithograph, $17 \times 22\frac{1}{8}$ in
Artist's proof, signed in pencil, lower right, 'Stanley Spencer'

Provenance: Given by the artist to Richard Carline, 1956

See previous note. This may be identical with *Barbed Wire at Cookham*, 1954, the lithograph exhibited in the Stanley Spencer Exhibition at Cookham, 1958 (38).

Lent by Richard Carline, Esq

94 Study for 'Christ Preaching at Cookham Regatta' 1952–53

Pencil and coloured chalks, 16 × 23 in

Provenance: In the artist's possession at the time of his death; purchased by Miss Shirin Spencer through Messrs Arthur Tooth and Sons

Exhibited: Cookham, Stanley Spencer Gallery, 1974 and subsequently

Literature: G. Spencer, 1961, pp. 84–87; M. Collis, 1962, pp. 218–19, 226

In a letter addressed to Hilda soon after her death in 1950, Spencer outlined his plans to paint a series of pictures around the central theme of Christ preaching at the Cookham Regatta. The sermon would be delivered from the old horse-ferry barge moored by the Ferry Hotel, Cookham bridge, to an audience ranged on the banks and in punts alongside. The Regatta he remembered was the fully-fledged Edwardian affair of his youth, described in detail by Gilbert Spencer (*op. cit.*). It appealed to Spencer as an opportunity to re-introduce Christ to Cookham, to the entire village turned out in his honour in over sixty related canvases. By the end of his life, the artist had made over sixty drawings, most of them in red chalk and had completed five of the oils. The central canvas, over 17 feet long, remained unfinished. It is for this, which belongs to the Viscount Astor and is on loan to the Stanley Spencer Gallery, Cookham, that the present drawing is preparatory.

Lent by Miss Shirin Spencer

95 Portrait of Lucy Dynevor 1959

Pencil, 15 × 11 in

According to Sir John Rothenstein, Spencer did this portrait drawing in September, 1959, two months before his death.

Lent anonymously

Illustrations

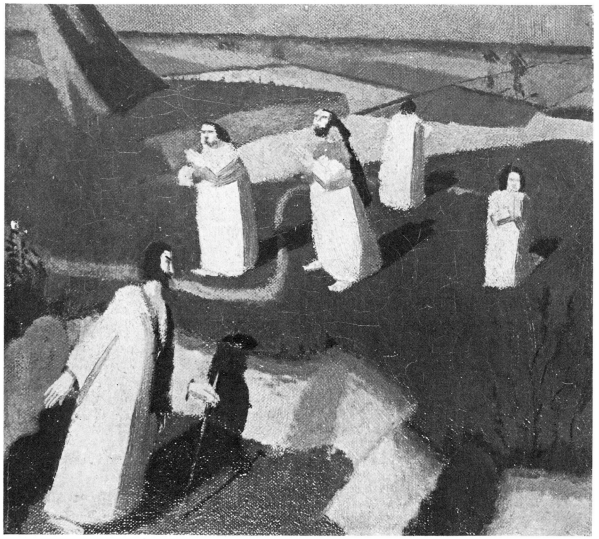

1 John Donne arriving in Heaven, 1911

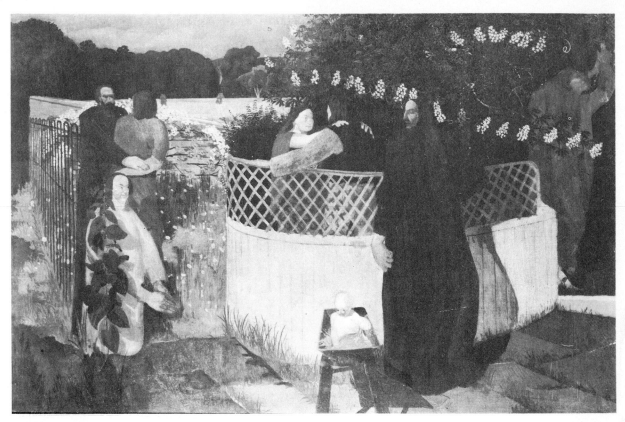

2 The Nativity, 1912

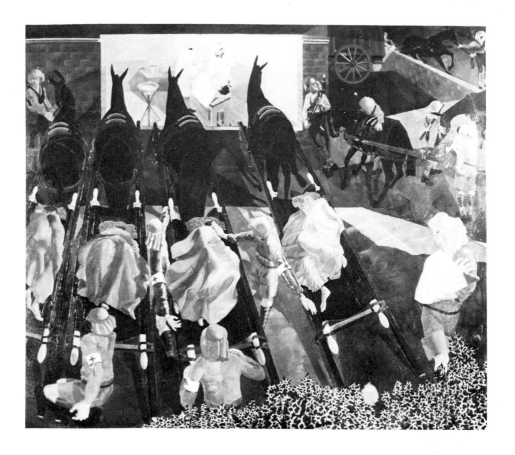

3 Travoys arriving
with wounded at
dressing-station,
1919

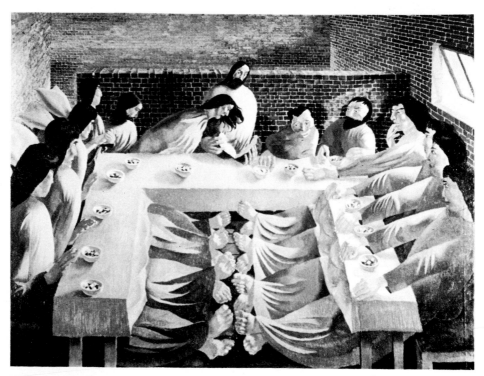

6 The Last Supper,
1920

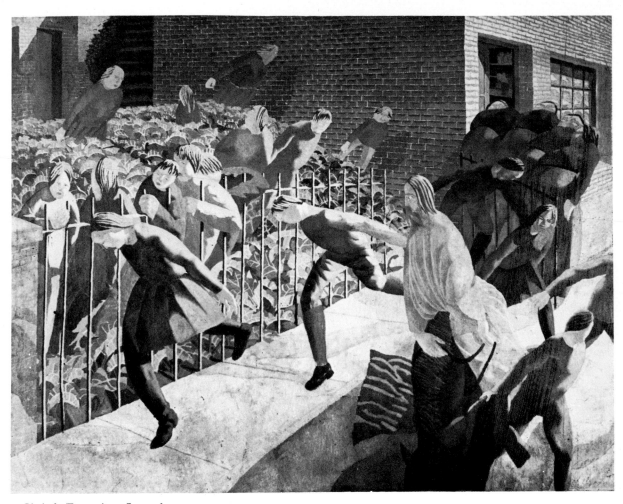

7 Christ's Entry into Jerusalem, *c.* 1920

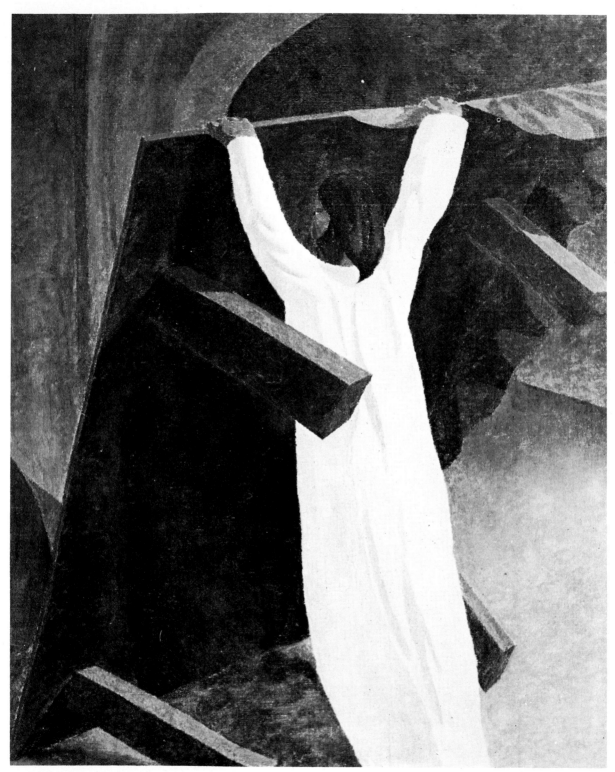

8 Christ overturning the money-changers' tables, 1921

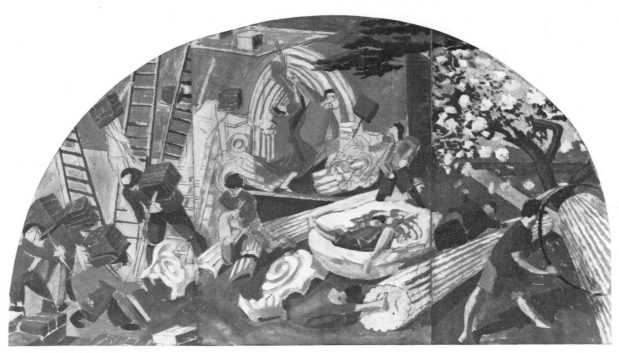

15 Building a church, *c.* 1930

17 The May-tree, 1932

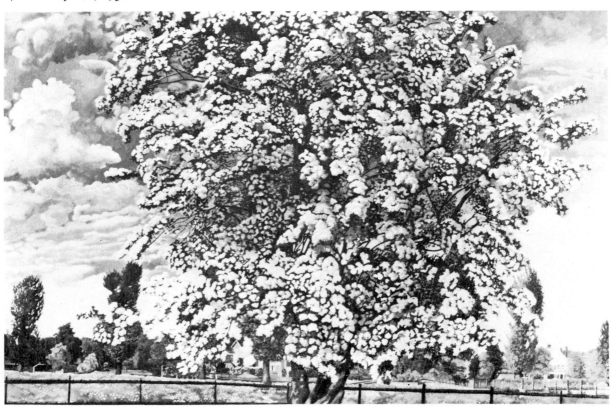

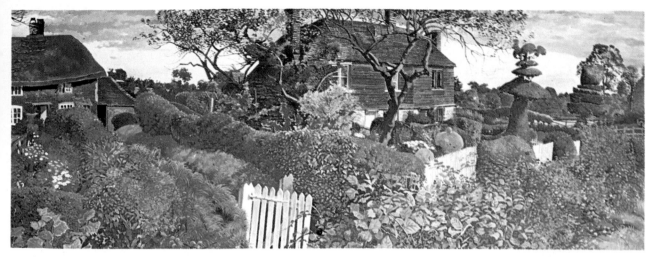

16 Cottages at Burghclere, *c.* 1929

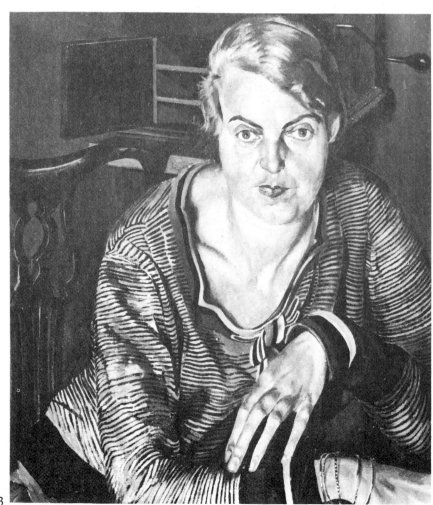

18 Portrait of Patricia Preece, 1933

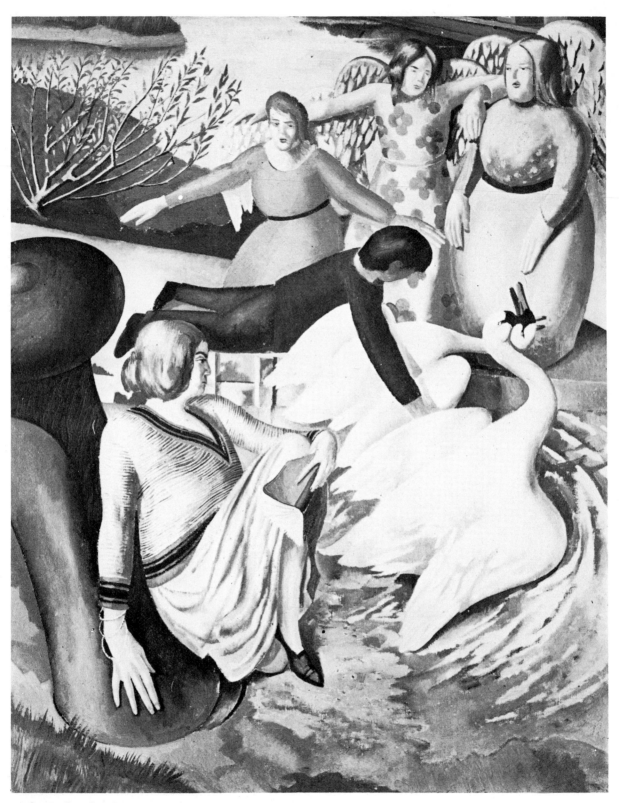

19 Separating fighting swans, 1932–3

20 Sarah Tubb and the
Heavenly Visitors, 1933

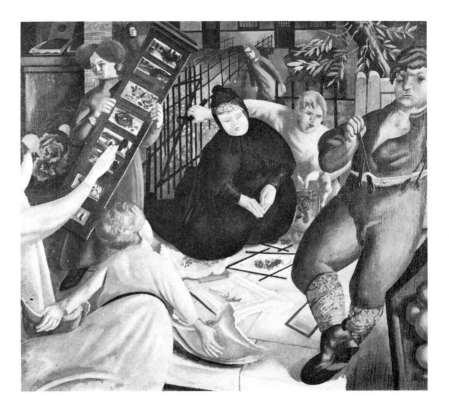

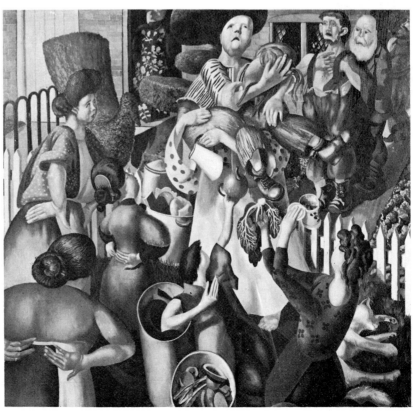

22 The Dustman or The
Lovers, 1934

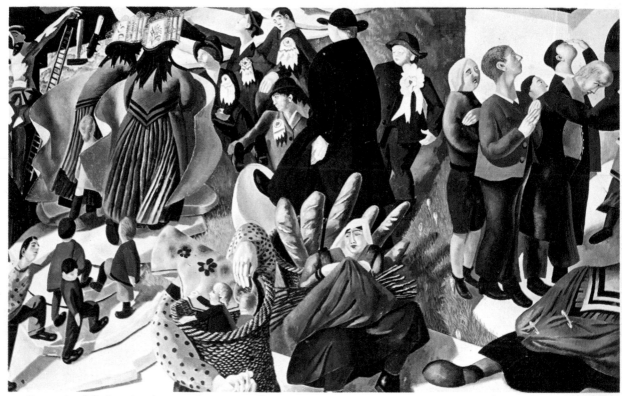

21 Souvenir of Switzerland, 1934 (*centre panel*)

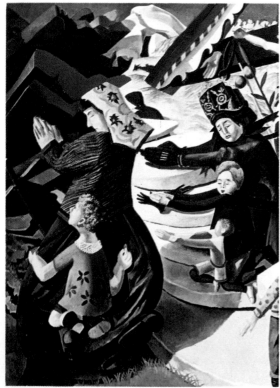

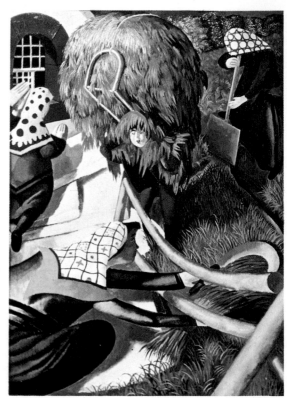

(*left panel*)

(*right panel*)

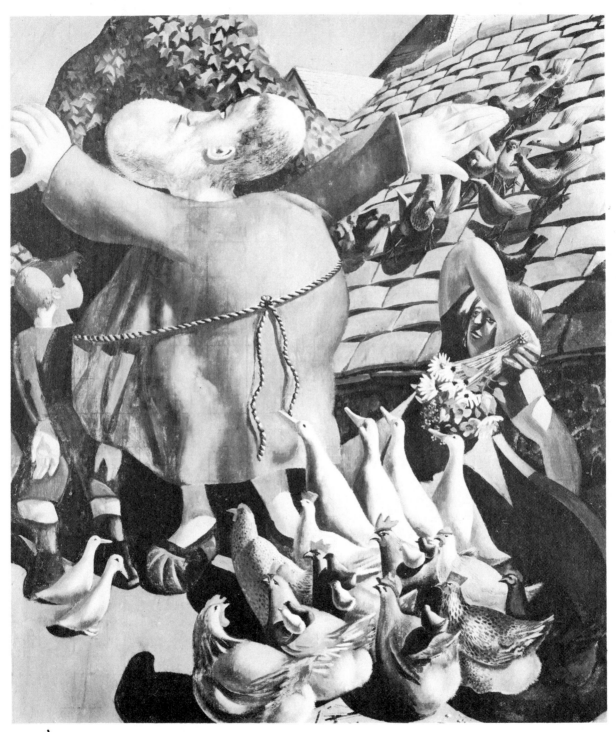

23 St Francis and the Birds, 1935

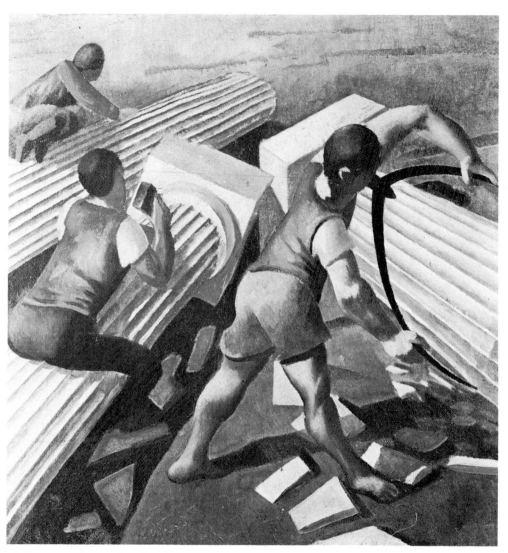

26 Making columns for the church, *c.* 1935

27 Love among the Nations, 1935–6

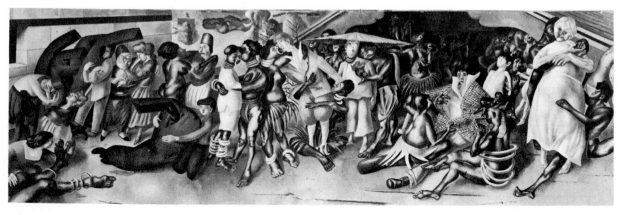

30 The Boat-builder's Yard, Cookham, 1936

31 Cookham Moor, 1937

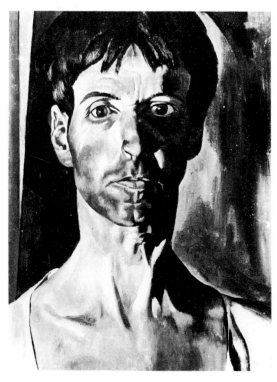

33 Self-portrait, 1936

34 Self-portrait with Patricia, 1936–37

36 Beatitudes of Love, V. Contemplation, 1937

38 Landscape in North Wales, 1938

64

40 The Wool Shop, 1940

37 Hilda, Unity and Dolls, 1937

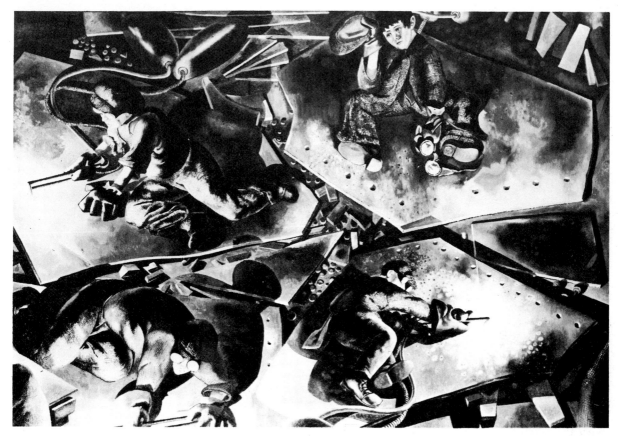

41 Shipbuilders on the Clyde: Burners (*centre panel*), 1940

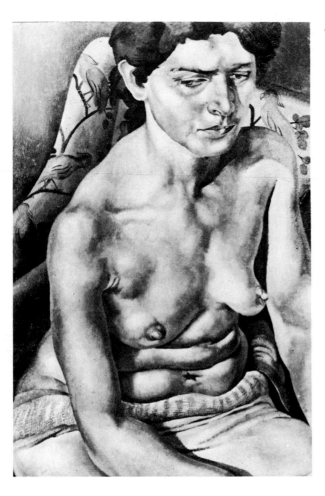

42 Seated nude, 1942

43 The Resurrection: Reunion, 1945

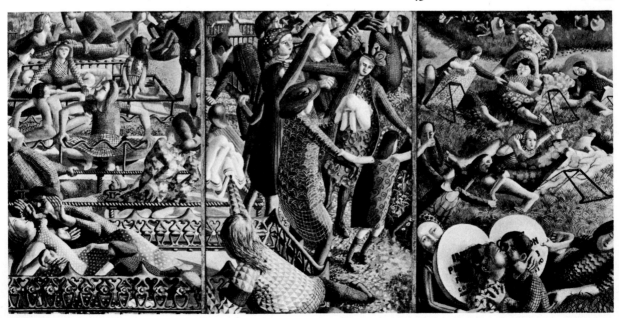

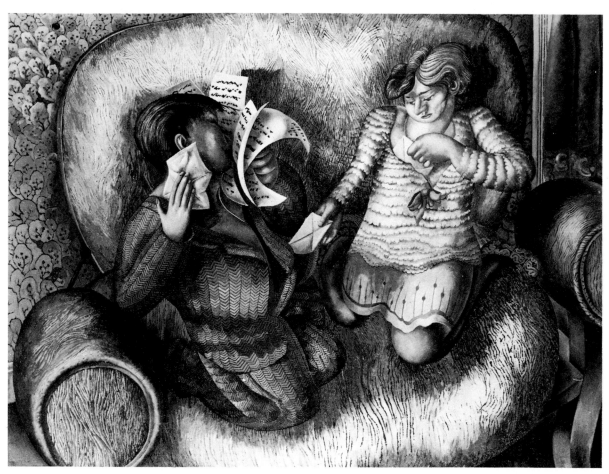

47 Love Letters, 1950

48 The Farm Gate, 1950

49 The Marriage at Cana: Bride and Bridegroom, 1953

50 Love on the Moor (*detail*), 1949–54

52 The Fairy on the Waterlily Leaf, 1910

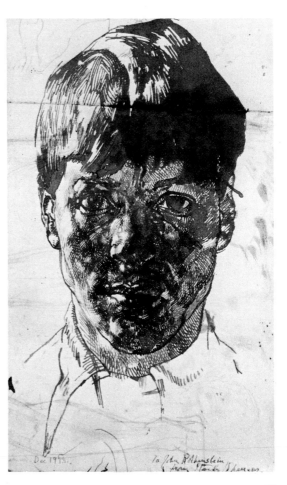

54 Self-portrait, 1913

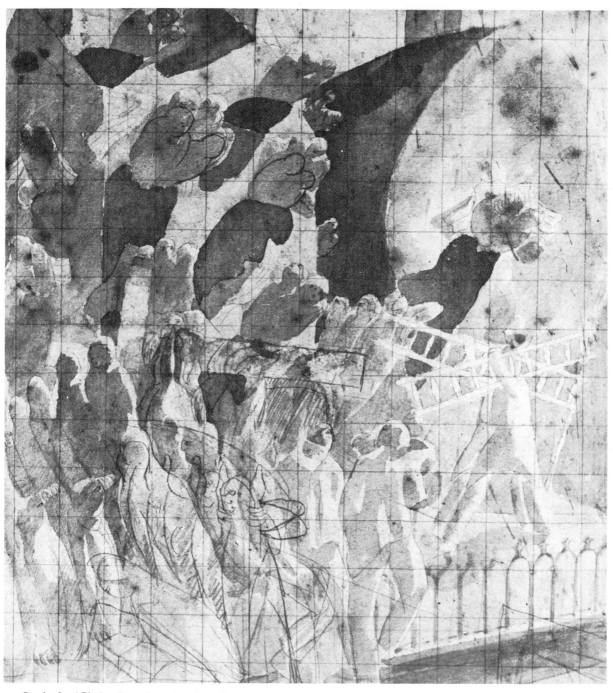

55 Study for 'Christ Carrying the Cross', 1919–20

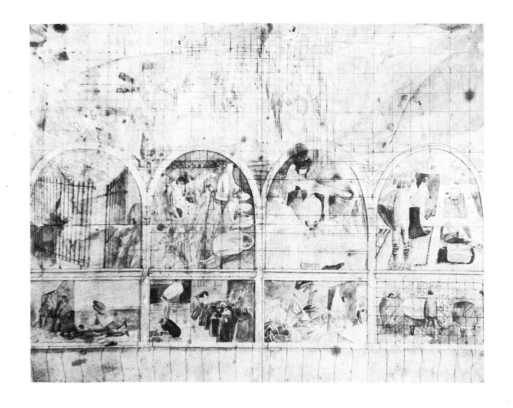

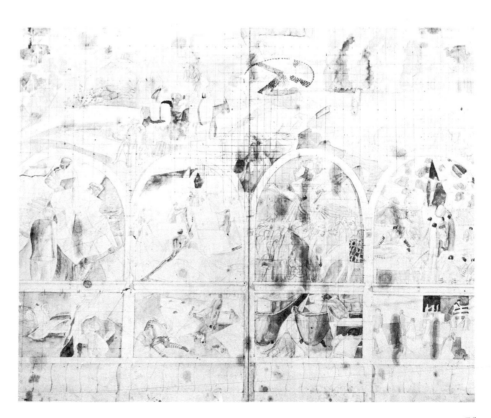

57 Study for
Burghclere Chapel,
south wall, 1923

61 The month of January: Afternoon tea, 1926

63 The month of December: Christmas stockings, 1926

65 Portrait of Mrs Carline, 1931

66 Hilda with hair down, 1931

73 Couple drawing each other, Stan and Mary
c. 1940

76 Taking in washing, Elsie *c.* 1943

77 Me and Hilda, Downshire Hill, 1944

79 Patricia dancing to the gramophone, *c.* 1943